U0164958

中国艺术之旅丛书

申伟光艺术20年

SHEN WEIGUANG

20 YEARS OF ART

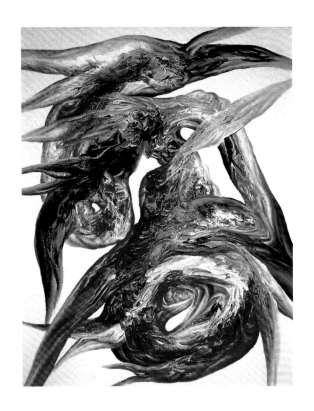

陕西师范大学出版社

李小山

坚硬的鲜艳

我们可以用一百种甚至更多的立场来评判当代艺坛，但是并非所有评判都符合事实，在伴随中国当代艺术一道成长的艺术家和批评家中，有许多已经远远落伍，如果重视或听信他们的说法，会闹出笑话。我曾再三思考和犹豫，是否还像以往一样把自己的批评家头衔当回事，很显然，眼下多元化及多样性所造成的喧哗与骚动覆盖了一切，沉默反倒更值得提倡，当然，我做不到完全的沉默，因为我毕竟不是瞎子和哑巴，出于自愿或非自愿，我仍有一些文字出现在某些读物上，这可能是我自身生活的惯性和别人出自友好的期待，所以，接到申伟光的电话，要求我为其作品写篇小文，便立刻答应下来。

我与申伟光有近二十来年的交往，虽然见面的机会寥寥，却经常在电话里通报近况，顺便谈谈艺坛的一些趣闻，有时也就某个观念或理论深入一聊。在我印象中，申伟光属于那种自我边缘化的人，一方面是因为他不肯轻易改变自己的立场，不肯俯就环境的压迫；另一方面是因为他天然的心性，正如他迷恋于宗教境界，将自己置于规律化的修炼之中，日复一日，以凿穿日常秩序对人的麻痹。我发觉，有一种人特别需要自我幻觉的滋养，不管这种幻觉来自宗教或自恋，而对于艺术创作，这是至关重要的。从申伟光作品的演变成熟来看，形式的置换和改变都是表面的，一条主线始终牢牢地缠绕于他，那便是试图在画面上体现他的个人思考，并将这样的个人思考嵌入观者的目光里。现代主义盛行的时候，大部分艺术家都有此种雄心，与消费时代的艺术家相比，显得比较沉重和灰色。毫无疑问，我们处在一个无法避免的社会转型期，从思想、感受及行为等等一系列方式上，都需要适应和应对，因此，思考的意义何在，或者说思考的沉重性是否有价值，显示出来的实质，是直接反应在画面本身的。我不相信一个艺术家可以离开作品来谈论其思想，如果作品与思想能够割裂，那仅仅证明他不是一流艺术家，这一点，我很赞成昆德拉对卡夫卡的评价。

我觉得，每次看到申伟光的作品都有不同的感受，说明他没有停止过向前挖掘，在他近年的作品中，有一个印象特别强烈：画面色彩越来越鲜艳。在此，我不想说鲜

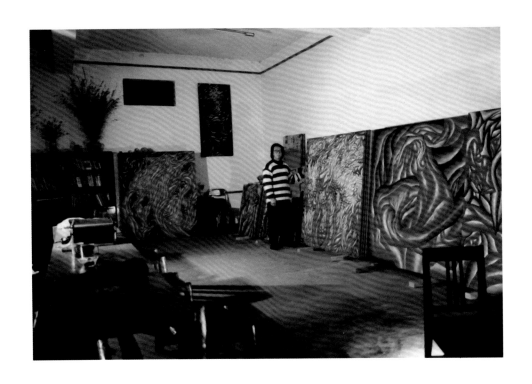

艳和沉稳之间的优劣，我的意思是，当作品趋向于艳丽和明朗的时候，是不是表明创作者内心的欲求起了变化？我们可以在一些艺术家、作家的传记中读到，由于生活景况的提升，前期的灰暗到了后期便开始明亮，这是生活迁移导致的心理变化，而这种变化曾经毁掉过一批有可能达到创作高峰的艺术家和作家。当然，任何经验只是一种提示，申伟光的创作是在双重矛盾下进行的，首先，他几乎是带有本能的反感面对消费主义时代产生的种种现象，换句话说，他的心态及精神状态与眼下流行的诸多方式格格不入，自我边缘化成了他的自我防空洞；其次，他的作品却或多或少完成了与时尚并无多少冲突的自觉的转换，尽管他同时也自觉地抵制了时尚的浅薄和猥琐。矛盾是他的一个突出特征，我的看法是，正是这种矛盾成就了他近年来的一批佳作，无论他用何种样式，抽象的或具象的，鲜艳的或灰暗，他内心的冲突都是显而易见的。

所以，我在他如此鲜艳亮丽的画面上看到了无时不在的坚硬，有时直接表露在画面本身，有时却是用隐晦的结构展露其难以排解的心曲，这就是他相对成功的方面，如果他没有把自己置于这样的境地，那么很可能会像许多一头钻进世俗利益里的艺术家一样，在埋没才华的同时也亵渎了自己多年来树立起的理想。我在以前的文章中谈到，我不是道德主义者，特别反感举着道德主义大刀砍伐与自己道德理想相左的人士，因为，艺术史有太多的例子告诉我们，一个利欲熏心的家伙也许正是万众瞩目的大师，但是，这并等于我们以此来放纵自己。申伟光给自身的创作所寻找的理由不带普遍性，这是肯定的，在多元化多样性的时代，一个申伟光的出现足以证明，创作空间是属于各个不同种类的艺术家所共有的，而申伟光在其中获得自己不可取代的地位，也证明了一个艺术家必须具有特殊性，哪怕这种特殊性仅仅属于个人的。我曾在申伟光的画室看过数十幅作品，对着他那些鲜艳逼人的色彩，那些似有似无的机理，那些想象力丰富的形状，等等，我很难予以言表，的确，用一种语言来转述另一种语言，遗漏的东西太多，并且还会添加不应有的误解。只有一个办法是准确的，那就是直接面对作品，它会告诉你一切，你所理解的和需要的。

In Rich Solid Colors

by Li Xiaoshan

In appreciating and reviewing works of modern art, we may proceed from over a hundred perspectives. However, not all critiques do them justice by telling a true story. Among artists and critics who grew into their maturity along with modern art in China, many have fallen out of line. If we still listen and give credit to what they said, we would make a fool of ourselves. I gave due consideration to and hesitated at whether I should take my title as a critic as seriously as I used to do. While pluralism and diversification have made the world boisterous and restless, remaining silence seems a recommendable choice. Certainly, I cannot keep my mouth tightly shut, after all, my eyes and ears are still functioning. Both out of my own will and that of others, my words have been published and can still be seen here and there, as motivated by either the force of inertia of my own life or good-will expectations of other people. Thus, at receiving Shen Weiguang's phone call asking for writing a small article on his works, I immediately agreed.

I came to know Shen Weiguang almost 20 years ago. Since then, despite a small number of meetings in person, we have exchanged frequent phone calls for casual talks about interesting news in the art circle and sometimes in-depth discussions over a specific idea or theory. In my eyes, Shen Weiguang falls within the type of people who intentionally marginalize themselves, not only because he takes a firm stand and refuses to compromise under the pressure of the environment, but also because of his state of mind, detached but religiously affiliated. By immersing himself in the religion and cultivating his mind on a regular basis, he has outgrown the paralyzing force of the mundane order. I have come to realize that for people like him, self-illusion, regardless of its origins, being it religion or narcissism, serves as the food for their minds and is at the very core of their artistic creativity. From Shen Weiguang's earlier works to more mature ones in recent years, displacement and changes of forms are quite noticeable, but deeply embedded is the overriding theme he persistently pursues - to project his personal thinking on canvas and by doing so his ideas would find their way into the eyes of viewers. At heart, most artists nourished the same ambition at a time when modernism prevailed, which might seem somewhat too serious and gloomy for artists in the era of consumption. There is no doubt that we are in the middle of a transformation which we cannot dodge but adapt our ways of thinking, feeling and behaving. Therefore, the meaning of thinking, in other words, whether serious thinking holds any value and what it reveals, would be directly reflected in the paintings. I doubt an artist can discuss his ideas independently of his works, and even if works and ideas were separable in his case, it simply means that he is not a first-class artist. In this respect, I share with Milan Kundera's views on Kafka.

I can always tell the difference each time I look at the works of Shen Weiguang, which testifies to the fact that he has never given up exploring. What is quite striking in his recent works is that the colors have become richer. I would not comment on whether brilliant colors or more reserved ones are better, but when works of an artist become brighter and richer in colors, doesn't it imply changes in his spiritual aspirations? As we may have read in biographies of some artists and writers, their works usually turned brighter along with improved living conditions, as compared with the dark tone at earlier stages. These psychological changes, as consequences of changes in life, ruined the career of many artists and writers who might otherwise have scaled new heights in tapping their creativity. All sorts of experiences are nothing but a clue to Shen Weiguang's artworks which were accomplished more by his paradoxical mind. On one hand, he has an instinctive aversion to all kinds of phenomena produced by the era of consumption. Another way to put it is that he finds his mentality and state of mind so out of tune with the mainstream thinking that he intentionally marginalizes himself as if building a shelter for himself. On the other hand, despite his conscious resistance against pervasive cheap snobbery, his works realize, more or less, a conscious transition without incurring any immediate conflict. One of the prominent features that highlight his works is paradox, which, in my mind, provides inspirations to his recent works, very impressive ones where internal conflicts are quite straightforward regardless of forms of his choice, being it abstract or concrete, bright or dark.

Therefore, I can discover everywhere in his paintings in rich and bright colors the solidness, sometimes explicit and right on the canvas, sometimes hidden within obscure structures, unfolding his unsettled mind. He is quite ingenious in accomplishing this and it is a accomplishment without which he would have deviated from his high ideals he has cherished for years and would have followed the suit of so many other artists who sacrificed their talents to their headlong pursuit of material gains. As I already mentioned in my previous articles, I am not all a moralist and singularly detest those people who denounce and attack others of different moral disciplines and ideals in the name of morality, as proven by numerous examples in the history of art where a renowned and much-respected person might turn out be someone greedily and recklessly going after profits and gains. Nevertheless, precedents provide no excuse to indulge ourselves. The motivations behind Shen Weiguang's own artistic endeavor are by no means universal. In this era of pluralism and diversification, the individual case of Shen Weiguang suffices to prove that the vast potential for creation is to be shared by artists in all categories. And that Shen Weiguang has earned himself a unique place in it demonstrates that an artist should have distinguishing features, even if these features are highly individualized. When I visited Shen Weiguang's studio and saw dozens of his paintings, I found it very hard to describe in words their dazzling colors, evasive textures, and richly-veined imagination among others. It is true that links are missing in retelling his works in another language without redundancy and misunderstandings. The only solution is to remain truthful, that is, to look at the picture face to face, listen to anything it tells, anything you need and can comprehend.

贾方舟

证悟生命的精神苦旅

——申伟光新作透析

还是在八年前，我曾为申伟光写过一篇评论，把他的画归类为"超验绘画"，把他的人规类为"唯灵论者"，把他的艺术倾向认定为一种"理性表述"。近几年，他的画发生了很大变化，他的"表述"不再那么"理性"，那么不留余地，而是融入了更多表现性的因素和感性特征。大约已有四五年光景，申伟光一张接一张地在画这些很感性的画，应该说，这是我所期待的一种结果，因为我不只一次鼓动他要画得放松些。但不知为什么，我在心理上却不大能接受这些作品。看着这些新作，我又很怀念那些画得很"理性"却充满张力的旧作了。但我并不因此而给出简单的结论，我宁肯反思我自己。因为我知道我和申伟光并不在同一个知识领域思考问题。他与佛的结缘把我屏蔽在他的精神领域之外。我不知道他的这些神秘图像为什么总让我感到潜隐着一种伤痛？这些抽象的生命意象为何会给我一种被撕裂、被扭曲、被刨切、被伤害的感觉？画家为何要把一个完整的生命体肢解、刨切开来加以呈现？我一直在思考：申伟光为什么要这样画？他想要表达的是什么？他的这些神秘图像和他的精神修炼之间到底是一种什么关系？我从不曾问过他，也不想多问，我想自己去思索、去找出一个合乎逻辑的解释。

我于是阅读申伟光写过的一些不长的文字，想从那里发现一些蛛丝马迹。却发现申伟光的过人之处：他只在佛学层面高屋建瓴地看艺术，看人生，却从不在自己所写的文字里具体地解释自己的绘画，这无疑是对的。因为通过绘画语言表述的意涵无需再用文字语言来转述，因为这种转述只能是一种框定，它会切断通往其他途径理解的可能性。所有明智的画家都不会轻易地去解释自己的画。

但毕竟，申伟光的文字表明了他的一种艺术态度以及艺术何为的理由。从他的艺术态度和对艺术的理解中，我可以确认我对他的艺术的直觉感受不是没有道理。因为这些作品正是他漫长艰难的精神苦旅的见证。他把艺术劳作看作是一种"精神修炼方式"，一种"悟道的媒介"，一个"藉假修真的过程"。通过这种修炼过程，来"消除无明烦恼和痛苦"，"把欲望和本能转化为愿力，经过升华实现出来"，"使精神转化和净化"，从而"创造出艺术的伟大精神样式"，使艺术成为"最高的精神实在"。这个为"消除无明烦恼和痛苦"、从"无明"走向"明"的过程，这个为把"欲望和本能转化为愿力"从而获得精神升华的过程，就不可能是轻而易举的和一帆风顺的，就必然要经历一场心灵的磨难和精神的苦旅。

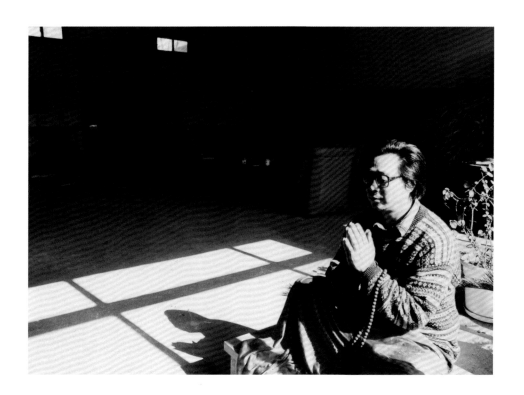

　　从作画过程看，申伟光的画在初期阶段是具象的，具象的人体在深入的过程中被逐步地解构、剥离、抽象化、符号化，以至最后蜕变为一种神秘的、不可知的形态。这个过程，实际上就是在用一种超验的方式，对生命"实在"作出一种"直观透视"，从而"使内心体验转化为可见的形式"，以"证悟真实生命的光辉和空灵"。画家通过"肢解"、"刨切"对生命实在所作的"直观透视"，虽予人一种痛感，却不是血淋淋的。这种"肢解"和"刨切"，只是用超验的方式对生命的证悟，而不是血腥的呈现，它甚至让人感悟到一种灿烂如花的生命火焰，因为它已升华为一种精神上"深度体验"。所以对生命的"肢解"与"刨切"，恰恰是以视觉方式对生命本质的追问、对生命的完整性和人格的完整性的渴望。

　　中国社会自从被导向消费时代以后，表面繁荣的背后是深重的精神危机。市场像一只看不见的黑手在钳制着艺术家的走向，把他们推向一种生存的尴尬和无奈。艺术家无论走到哪里，都无法摆脱这个精神阴影。要么向它就范，要么与它抗争。面对这样的生存局面，申伟光把艺术看做一盏光照"心灵黑暗"的灯，看做是"提升人的精神生活使之不再沉沦的精神样式"。他没有抱怨这个恶俗不堪的外在世界，而是把艺术家的堕落归结为"本性的无明"："当堕入物欲的横流，黑暗和罪恶便从人的心中升起，艺术家的精神品质丧失，使艺术的伟大光环变得暗淡，艺术已成为艺术死亡后的化妆"。从这里我们不难看出画家如何以一种清醒自觉的意识，为获得精神的救赎、为求得心灵的平静所作的抗挣，从他的作品中所渗透出来的那种隐隐的伤痛，正是在他证悟生命的精神苦旅中必然会有的一种感觉，否则，他的精神超越就失去了一种内在的真实性。

<div style="text-align: right">2004年7月8日　于北京京北上苑</div>

Spiritual Pilgrimage towards the Truth and Epiphany of Life

—Insights into recent works by Shen Weiguang

by Jia Fangzhou

In my critique on Shen Weiguang's paintings eight years ago, I classified his works as "transcendental paintings", him as a "spiritualist", and his artistic inclination as "rational representation". Great changes have taken place in recent years as his "representation" becomes less exclusively "rational", but introducing more expressionistic elements and perception. For about four or five years, Shen Weiguang produced, one after another, paintings imbued with sensibility, which, I should say, was what I had expected, since I had, on many occasions, encouraged him not to overstrain himself and to touch on lighter themes. However, I found it hard, psychologically, to accept these works for reasons even unknown to myself. His most recent paintings made me reminiscent of his the earlier ones, rational yet forceful. Nevertheless, I would not arrive at a conclusion out of hand. Rather, I would reflect on my own ideas after acknowledging the fact that Shen Weiguang and I were not thinking in the same sphere of knowledge. His spiritual attachment to Buddhism screened me off his mental world. I felt mystery as to why these mystic images were invariably tinted with subtle pains, why these abstract images of life struck me as if they were severed, distorted, disintegrated and impaired, why the painter dissected and disintegrated the living body in its wholeness for presentation. I kept wondering why Shen Weiguang sought to paint in this way. What did he intend to convey? What was the relationship between these mystic images and the way he cultivated his mind? Never did I challenge him with these questions nor did I wish to do so. Rather, I would explore and find out a reasonable answer on my own.

It was then did I begin to read some of his articles, not very long ones, for clues. As I went along, some outstanding features of a different Shen Weiguang came into light. He perceived art and life from the Buddhist viewpoint, full of vision and foresight, but never had he spared a single word in his articles in trying to explain his paintings. This was, no doubt, the right choice, since it was unnecessary for meanings already explicit in paintings to be explained again in written words which could do nothing but confine and deny alternative ways in understanding. No wise painters would ever rush to explain their paintings.

Despite this, Shen Weiguang's articles did reveal his attitudes towards art and his reasoning about what art was for. As his views towards and understanding of art became salient, I was quite sure that my intuitions about his paintings were, to some extent, justified. His recent works bore witness to his long and arduous spiritual pilgrimage. In his eyes, artistic endeavor was "he means to refine the mind", "the medium towards epiphany", and "the process to seek truth from virtuality". Such a refining process would "eliminate darkness, anxiety and anguish", "transform desires and instincts into willpower through sublimation", "convert and purge the mind", and thus "constructing a great spiritual model of art" and "elevating art to the highest spiritual being". This process of achieving "enlightenment" out of "sheer darkness" by "eliminating darkness, anxiety and anguish", of elevating the mind by "transforming desires and instincts into willpower", was anything but an easy and smooth sail. The painter was doomed to embark on a spiritual pilgrimage that subjected him to misery and torture.

As regards his paintings, Shen Weiguang began with concrete and substantial images, which were, as he pressed forward, gradually deconstructed, estranged, laden with abstraction and symbolization, and finally transmuted into a mystic and evasive form. This was achieved virtually by transcendentalism which rendered him a "direct visual perspective" on the "true being" of life so that "inner experiences are presented by visible means" to "make truth and obtain epiphany of the true being, glorified and free". The "direct visual perspective" on the true being of life achieved through "dissection" and "disintegration", albeit the pains they provoked, did not at all bloody, since such "dissection" and "disintegration" were only means of transcendentalism for the epiphany of a true life. It might go even further to expose people to a splendid life radiating in burning flames, because it was sublimed to some sort of "inner experiences" of the mind. It followed that the dissection and disintegration of life symbolized nothing but interrogations to the intrinsic nature of life through visual means and the quest for the wholeness of life and moral integrity.

Ever since China ushered in the consumption era, serious spiritual crisis looms large behind superficial prosperity. The market maneuvers where artists are heading like an invisible black hand, shoving them into dilemma and depriving them of choices to live off. Artists sink so deep into this spiritual crisis that it casts shadow over every step they make. The question remains: to be or not to be. Challenged by such conditions for survival, Shen Weiguang views art as a lamp that sheds light into the "darkness of heart", a spiritual model that "elevates the minds and stops them from degradation". The degradation of artists, as he sees it, has less to do with the external world of excruciating vulgarity than with their own "dark nature", according to his words, "when overwhelmed by the materialistic desires, darkness and evil spirit rise from the depths of human heart, shattering moral integrity of artists, tarnishing the glory of art, and degenerating art into a sheer gloss on the dead body of art." Given this, it becomes quite evident how the painter has been struggling with sober consciousness for spiritual redemption and peace of mind. Subtle pains that permeate his works are unavoidable in his tough spiritual pilgrimage to make truth and obtain epiphany of life, or, his spiritual transcendence would be deprived of inherent truthfulness.

July 8, 2004 Beijing

岛子

异在的图式及其延异

　　经由漫长的草创之路，穿越遍在的语言牢笼和整体的意义网络，申伟光的油画艺术形成了异在的二重性视觉形态，即由有文化教养的智识者对外部世界审视和有意识的、深刻的内心体验构成的产物。异在的"精神向度"，显示了这位潮流之外的艺术家的语言论转向后业已转变了的意识状态，他摆脱了自明与全能的期待，并试图在时代的惯性和约束网络中厘清鳌乱、勘察途径、禀明关键的联系。在一个不断边缘化的移置（Displacement）过程中，他渐次摈弃了有关理性王国宰制的本质、内容和世界观问题，转而以现象、形式和具体知识相关的"意象制作"（Image making）为中心，来营造生存中最重要的主题，以细致入微的设问取代精神史的一般概括。这一"有向度的精神"探求，同时也回应着贡布里希著名的命题："艺术家的倾向是见其所欲画，而非画其所已见。"

　　申伟光创作形态的异在化之特殊性表现在由线型符号构成的延异（Differance）的图式。他的整体图像在某些观者看来是抽象的，而具体的构成图像的细微形体则是一种陌生化的具象。纯粹的具象描述，属于技术和技巧范畴。纯抽象则是想象力的产物。在此二者之间，画家运用线型符号编织出中介的引渡，那就是意象性符码（Gymbolic Code），这是画家在长期的发展中形成的具有特定含义的可辨认意象模型。

　　"申氏图式"的提示，并非仅仅为了阐释的捷便，在本文语境中，它的差异性，为在场确立了当代艺术形态中重要的一维，它的存在区别于一般认识论的物质压力下的反映，也区别于对意识形态神话的附丽或者单一逻辑的对抗。体认这种图式的有效标识，首先是线型符号要素，线条有自己的历史处境，它即是现代生活的命脉，又有它处身的时代特性。在形式上，它所生发的意象从来不是绝对的，正像申伟光创造性的运用那样，它的相互纠缠、轧结、盘绕、纠纷，引伸出动态的紧张和心理鳌乱，因而本原的自然之线，转换为意象化了的节奏集群的首要基础。

　　意象化的蛇型线条，满足着不同观者的期待视界（horizon of expectation），正像贡布里希所言"对图式的需要其实是对符码的需要"，因而，意象读解（image reading）的差异，由观者或批评家据以一定心理定势去产生对视觉图式的预测、等待或期待心理状态。

　　而所谓"投射"则是将这种期待不断尝试着移入视觉对象中，反复试错，从而获得视觉图式的过程。蛇型线被差异性的读解还原，有时是铁丝、钢条、胶管电缆或织物一类的无机物，而它们的穿插、牵引、盘结、缝缀，往往以施虐狂式的暴虐，"权力利必多"式的抽搐，偏执狂的动名词式的刺痛，对有机的生物符征施行技术化的"手术"，或者，据以色彩，那种近乎原色的强烈对比去消费它喜剧性的效果。或者从视觉的分类中，感受"浓厚的工业文明趣味"。虽然说读解的症候表明某种"人言人殊"，但其背后却隐匿着相似的心理症候。我们必须承认，所有的期待都源于某种"缺席"，而现代人所谓"看画"已然是一种带有智性之思的"阅读"，绘画的视觉符号有拟语言的属性，而所有拟语言都是视觉思维

(Visual thinking)的"辅助媒介",由此作用于观者的分类、稳定和突现,进而密切介入知觉系统。在此,维特根斯坦的图式论,同样适用于对申伟光作品的诸种读解现象的阐释,维氏认为,"图式关系即存在于图式的要素与事物的对应之中",而这些现实关系实际上是"图式联系现实的触角",以此推论,联结图式各个组成部分的结构方式必然和联结被描绘的现象的结构相一致。这种在图式和现实中保持一致的结构被维特根斯坦称为"图式的形式"(Pictorial form)。这里的引证意在印证,申伟光图式的中心地位既存在于自身的意象创作中,也存在于意象读解中。

于是在图式的名义下,形成一种自足的语言,浸入画家隐秘的迷思中。图式是他的隐居之所。这种秘密也设定了画家与社会、本质、情感动力、历史背景的距离,却又向它们显现。也可以说,它的语言逻辑位于把画家和社会联系起来的契约之外。所谓"非理性的表现",对申伟光的图式是这样的一种指谓:它是一种盲目的固执的变形结果,一种从本能与世界交汇处滋生的血肉之躯的未知的装饰音。这其实是一个理性的感性化过程的逆向推衍。

在某些批评家看来,申伟光的"图像表述与文字表述之间尚存在距离"(贾方舟评语,见于《一个唯灵者的理性表述》),或者认为"在造型语言过分的明晰性和硬性色彩,妨碍了他艺术主题的丰富性和神秘性的表达"(见邓平祥《灵性生命的图示.精神律动的符号》),再有论者陈孝信在《十年磨剑》中指出,"由于他过分热衷于超然的精神结构,提纯和剥离的幅度又相对有限"因而"有损于艺术自身的丰富和深度的展开"。以上三种批评指陈,其实都囿于申伟光所提供的文本《自述》去"按图索骥",事实上画家的文本和图像是一种意指关系的运动,后者是对前者的无意识"涂改",其图像的存在经由"涂改"的符号而存留的某种不可还原的"痕迹",这些"痕迹"的流变就像赫拉克利特之河:永远是自己又是别的。三位论者的持论支撑点基于逻各斯为中心的认识论,其期待心理出于拟语言和文字的对立,进而寻求创作主体和意识的主宰地位,这无非是论者们在想象中通过抽象之思按照逻各斯的动机得出的"判断"。画家的文字表述与图像表述恰恰透露出两种不同表达的意谓。德里达在《作为自白的"意谓"》一文中指出,表达"是承担意义的一种符号","诸种表达则是意谓的符号"。"意谓针对的是外在的——它是理想对象的外在"。表达即意谓的"能指",非语言符号本身即是"能指"的衍生,这在申伟光的图像表达中,明显地"悬搁"起文本表达的"所指"而专注于视觉符号的"能指"结构,他抛开文字的意谓的根本原因,或许正因为自在的意义必须由大于所指的视觉意象来表达,由此二者的非对等非确定性的差异和痕迹流散布施,这正是"延异"的生成所在,"延异"是差异和差异之痕迹系统的游戏,也是间隔系统的游戏,正是通过间隔,要素之间才相互联系起来。

申伟光图式本身的"延异",也同样设定了两重意谓:其一是差异或区分,其二是延缓或迟滞。在论者们期待的主题的丰富性和神秘性"存在的距离"以及"超然的精神结构"全部"缺席"的背后并没有必然的"存在"而只有"延异","延异"在这位异在画家的图像/文本中的作用在于,它把"存在物"不再引向"存在"这一想象的"中心",而是逆向移置于边缘地带,所谓"移心"(decentrement),即奔向非中心、非结构、非整体的"冲突中的新秩序"(申伟光语)。

在语言的帝国城堡游移的卡夫卡曾在《对罪愆、苦难、希望和真正的道路的观察》中指证:"真正的道路在一根绳索上,它不是绷紧在高处,而是贴近地面的。"这一关于虚无意志的辩证式箴言,如今在申伟光的视域得以经验化的印证和超验化的表征,它不仅是异在者的"天路历程"或图像志,或许,被表征着的"绳索"意象本身,即人类的上下求索的突围之路?

Pictorial Form of the Other and Its Differance

Dao Zi

Having traveled a long journey of tentative steps and through the omnipresent linguistic bondages and the intriguing mist of meaning, Shen Weiguang has achieved, in his oil paintings, a dual visual form of the Other, as a result of his observations on the outer world as well as of his conscious and profound inner reflection as a well-bred man of knowledge and thinking. This "spiritual dimension" of the Other indicates that his state of mind, beyond the tide of the times, has been transformed after his language system was redirected. While freeing himself from high hopes for self-enlightenment and omnipotence, he has attempted to penetrate through all the mist and mess, find his way out and define the crucial links amidst the force of inertia and constraints of the times. In a continuously marginalized process of displacement, he has gradually turned away from concerns for the essence, content and outlook of the world ruled by the kingdom of reason. Instead, he focuses on images related to phenomena, form and concrete knowledge, in hopes of constructing the most important theme in existence, replacing the simple generalization of the history of the mind with fine-tuned inquiries. Such a pursuit of a "dimensional spirit" echoes with the famous proposition of E. H. Gombrich that "artists are inclined to see what they desire to paint rather than paint what they see."

The art form of the Other created by Shen Weiguang is quite exceptional in its being a pictorial form of differance consisting of symbolic lines. The whole picture may seem abstract to some viewers, whereas it comprises of specific unfamiliar tiny images and objects. Pure description of concrete images is a matter of technology and techniques while pure abstraction is at the mercy of imagination. Between the two ends, the painter employs symbolic lines as a medium of transition, which is known as the symbolic code, a visually discernable imagery model with specific implications developed by the painter through years of practice.

"Shen's Pictorial Form" is therefore coined not simply for the convenience of analysis, but for the fact that its difference, in the context of this article, creates another key dimension of modern art. It stands in contrast to a simple reflection under the material pressure of a generalized epistemology. It is also distinct from a polish over the ideological myth or a confrontation against the single linear logic. To identify and understand the effective labels in this pictorial form one should begin with the elements in the symbolic lines that have their own historical context. They are the lifeline of the modern times which also retain features of the historical period they belong to. Images created by the symbolic lines are never absolute in meanings. As in the creative hands of Shen Weiguang, they are entangled, woven and coiled together, entailing dynamic tension and mental disturbance. In such way, the original natural lines are transformed to form the chief foundation for images created by rhythmic clusters.

Snake-shaped lines laden with images gratify different horizons of expectation held by different viewers, as Gombrich claimed, "the need for pictorial form is in essence the need for symbolic code." Therefore, discrepancy in image reading occurs when viewers and critics apply certain mindsets to arouse the state of mind in which they predict, await and hold expectations for the pictorial form. "Reflection", on the other hand, refers to the trial-and-error process of obtaining visual pictorial form by making continuous attempts to transplant such expectations into the target object. The snake-shaped lines are restored by different interpretations. In some cases, inorganic objects such as iron wires, steel bars, rubber cables or fabrics are interwoven, towed, twisted and sewn together to inflict technical "surgeries" on symbols of organic features as if by means of sadistic violence, convulsions under "power libido", or acute pains from strong biases. In other cases, colors are applied in a contrast almost as sharp as among the primary colors to produce a comedic effect. Visual senses may also be classified to witness the "overwhelming industrial civilization". Behind the symptoms of interpretation which indicate that "different people hold different opinions" hides a similar psychological symptom. We have no choice but to admit that all expectations originate from "absence" of some kind. To "view a painting", as in the eyes of people in modern times, has already become a sort of "reading" with intelligent thinking, since the visual symbols in paintings carry features of a quasi-language. As a "supplementary medium" for visual thinking, all quasi-languages are able to access the perceptual system by affecting the process of classifying, stabilizing and highlighting by the viewers. In this respect, the Wittgenstein's "picture theory of meaning" can be used to spell out different interpretations of works by Shen Weiguang. Wittgenstein claimed that "pictorial relationship consists in the correlation of the elements of the picture with things", while pictorial relationship is, by virtue, "antennas of pictorial form to correlate with the reality". It can be inferred that the elements of a picture are related in the same way as the phenomenon it depicts. This common feature of a picture and the reality it depicts was referred to by Wittgenstein as "pictorial form". By quoting Wittgenstein here, I wish to emphasize that the importance of Shen Weiguang's pictorial form lies not only in his creation of images but also in their interpretations. In the name of pictorial form, a self-sustaining language is formed and is instilled into the meditation of the painter who withdraws himself to pictorial form as his retreat. He alienates himself from the society, from its essence, emotional motivation and historical background, but simultaneously he demonstrates himself to them. Another way to put it is that the linguistic logic of his pictorial form remains independent of the covenant between the painter and the society. The so-called "irrational presentation" in the case of the pictorial form of Shen Weiguang, is the result of a blind and unswerving pursuit of metamorphosis, striking an unfamiliar ornamental musical note of the body born, in flesh and blood, from where instincts meet the world. It is, in effect, a reversed process of inference from reason to perception.

申伟光艺术 20 年

Some critics maintain that "discrepancy still exists between Shen Weiguang's pictorial and linguistic presentations." (Jia Fangzhou, Rational Representation of a Spiritualist), while others believe that "the language of imagery, excessively clear-cut and rigid, stands in the way of presenting his rich and mystic artistic theme." (Deng Pingxiang, Pictorial Representation of the Spirit and Symbols of a Dynamic Soul) Chen Xiaoxin, a critic, pointed out in his book Ten years in Sharpening the Sword that "his overdue interest in the transcendental mental structure, coupled with a limited scope for refinement and extraction," results in "undermining the deepening and enrichment of art for its own sake". The above-mentioned critical ideas actually refer back and are confined to the original text of Shen Weiguang's "My Own Opinions". In fact, the text and the images provided by the painter are correlated in meaning with the latter performing as an unconscious "alteration" of the former. The images contain irretrievable "vestiges" left by "altered" symbols. These "vestiges" mutate just like Heraclitus' river of flux, always as the same being and the Other being. These three critics all ground their views in the epistemology based on the logocentralism. With their expectations deriving from the opposition between quasi languages and written words, they pursue the overriding role of the creative subject and consciousness, which is nothing but a judgment made by their abstractive imagination following the logos motivation. Quite the contrary, the painter's linguistic and pictorial presentations are referring to two different ways of expressing meanings. In his article Meaning as Self-Confession, Jacque Derrida asserted that expression is a kind of sign that carries meaning, that different ways of expression are signs of meaning, and that meaning targets at the external - the external of an ideal object. Expression is the "signifer" in meaning while non-linguistic signs are, in themselves, derivatives of the "signifer". In the pictorial depiction of Shen Weiguang's

works, the "signified" of the textual representation is quite obviously "suspended" while attention is focused on the "signifier" structure of visual symbols. Fundamentally, it is because the meaning itself must be expressed through visual images larger than the signified that he discards meanings of words. Thus the non-symmetrical and indeterminate differences and traces are disseminated, giving rise to differance as a game between differences on one side and systems of traces resulting from differences on the other. This is also a game among systems of intervals which combine different elements.

The "differance" in Shen Weiguang's pictorial form renders dual meaning, the first being difference, the second being deferral. There is no necessity of "being" but only "differance"hides behind the "existing discrepancy" in presenting the rich and mystic artistic theme as expected by critics and the total "absence" of the "transcendental mental structure". The role "difference" plays in the images and texts of this alienated painter is that it moves the "objects of being" no longer towards "being" which has served as the "center" for imagination, but reversely to a marginalized zone. This is a process of "decentrement" towards the non-central, non-structural and non-integral "new order amidst conflicts" (by Shen Weiguang's definition).

Kafka, roaming in the Castle of the Kingdom of Language, stated in "Observations on the True Road Out of Punishment, Misery and Hope" that "the true road is on the rope, a rope not stretching tight high above, but pressing close to the ground." This dialectical parable about nihilistic will is empirically proved and transcendentally depicted by Shen Weiguang's images, epitomizing not only a pilgrimage but also a collection of images by this alienated painter. Or rather, is it probable that the image of "rope" itself symbolize the way mankind has been up and down to break free?

申伟光简历

1959 年　生于河北省邯郸市。

1981 年　河北轻工业学校美术专业毕业。

1988 年　南京艺术学院美术系结业。

1994 年　居住北京圆明园艺术家村。

1997 年　定居北京上苑，职业画家。

个展

1988 年　申伟光画展，南京艺术学院美术馆。

1996 年　申伟光作品展，北京 TAO 画廊。

1997 年　申伟光作品展，北京古老画廊。

2005 年　申伟光新作展，北京新锐艺术计划。

群展

1984 年　第六届全国美术作品展览，南京江苏省美术馆。

1986 年　河北七青年画家展，石家庄工人文化宫。

1990 年　1990 年全日本各地巡回中国美术交流展。

1992 年　首届九十年代艺术双年展，广州中央酒店国际展览中心。

　　　　中国当代艺术研究文献展，广州美术学院。

1994 年　第八届全国美展，石家庄河北省博物馆。

1995 年　中国现代绘画展，德国曼海姆市、卢德维希港市。

1996 年　开放的语境——'96 南京艺术邀请展，南京江苏省美术馆。

　　　　现实：今天与明天——'96 中国当代艺术展，北京国际艺苑美术馆。

　　　　中商盛佳 '96 中国当代艺术拍卖会，北京。

1997 年　'97 国安五龙秋季油画雕塑专场拍卖会。

1998 年　反视——自身与环境当代艺术展，北京建设大学。

1999 年　六人联展，北京希尔顿酒店观景廊。

　　　　北京翰海中国油画 '99 迎春拍卖会，北京。

2000 年　上苑艺术家工作室开放展，北京。

　　　　平面：北京当代绘画邀请展，北京中国妇女活动中心。

2002 年　北京上苑画家村艺术家作品展，澳门。

　　　　首届中国艺术三年展，广州艺术博物院。

　　　　长春当代艺术年度邀请展，长春远东艺术馆。

　　　　上苑艺术家作品展，北京炎黄艺术馆。

　　　　当代油画专场拍卖展示会，北京中华世纪坛艺术馆。

2003 年　赶集——当代艺术文件大展，北京香格里拉艺术公社。

　　　　中国当代艺术百人展，北京大陆艺术家画廊。

　　　　中国嘉德 2003 广州夏季拍卖会。

　　　　中国当代艺术年度文献提名展，北京艺森画廊。

　　　　"北京"当代艺术展，北京上苑艺术中心。

　　　　首届罗曼艺术沙龙艺术精品展，北京罗曼俱乐部。

2004 年　"表情·状态"中国当代艺术展，上海洁思园画廊。

　　　　88 艺术文献仓库第一回展，北京。

2005 年　辉煌——宋庄十年邀请展，北京宋庄艺术基地。

Resume of Shen Weiguang

Settled down in Shangyuan, Beijing, as a professional painter	1997
Lived at the Artists Village at Yuanmingyuan, Beijing	1994
Completed the diploma courses in the Department of Fine Arts of Nanjing Arts Institute	1988
Graduated as a fine arts major from Hebei Light Industry School	1981
Born in Handan, Hebei Province	1959

Solo Exhibitions

Exhibition of Recent Works by Shen Weiguang, Beijing New Art Project	2005
Shen Weiguang Art Exhibition, Beijing Gulao Gallery	1997
Shen Weiguang Art Exhibition, Beijing TAO Gallery	1995
Exhibition of Paintings by Shen Weiguang's, Art Gallery of Nanjing Arts Institute	1988

Group Exhibitions

Glory: Song Zhuang Ten-Year Invitation Exhibition, Beijing Song Zhuang Art Base	2005
Expressions and States - China Contemporary Art Exhibition, Shanghai Chelesa Art Co., Ltd.	2004
1st Round Exhibition of 88 Art Documents Storehouse, Beijing	
Attending Fairs - Great Exhibition of Contemporary Art, Beijing Shangri-La Art Commune	2003
China Contemporary Art Exhibition of 100 Artists, Beijing Mainland Artists Gallery	
Summer Guardian Auction, Guangzhou	2003
Nomination Exhibition of China Annual Archive of Contemporary Art, Beijing East Gallery	
"Beijing" Contemporary Art Exhibition, Beijing Shangyuan Art Center	
The First Selected Artworks Exhibition of Romance Art Salon, Beijing Romance Club	
Art Exhibition of Beijing Shangyuan Artists, Macao	2002
The First Triennial of Chinese Art, Guangzhou Museum of Art	
Changchun Annual Invitation Exhibition of Contemporary Art, Changchun Far East Museum of Art	
Art Exhibition by Shangyuan Artists, Beijing Yan Huang Art Museum	
Contemporary Oil Painting Auction Exhibition, Millennium Museum Beijing	
Opening Exhibition of Shangyuan Artists Studio, Beijing	2000
Graphics: Beijing Invitation Exhibition of Contemporary Painting, Beijing China Women's Center	
Joint Exhibition of Six Artists, Observation Lounge of Hilton Hotel Beijing	1999
'99 Beijing Hanhai Spring Auction of China Oil Paintings, Beijing	
Retrospect - Individuals and Environment: Contemporary Art Exhibition, Beijing University of Architecture	1998
'97 GAWL Autumn Auction of Oil Paintings and Sculptures	1997
Open Context: '96 Nanjing Invitation Art Exhibition, Jiangsu Provincial Art Museum, Nanjing	1996
Reality-Today and Tomorrow: '96 China Contemporary Art Exhibition, Beijing Crown Plaza Gallery	
'96 Sungari Auction of China Contemporary Art, Beijing	
China Modern Paintings Exhibition, Mannheim and Ludwigshafen, Germany	1995
8th National Exhibition of Arts, Hebei Provincial Museum, Shijiazhuang	1994
1st Biennial Art Exhibition of the 1990s, International Exhibition Center of Guangzhou Central Hotel	1992
Documental Exhibition of Chinese Contemporary Art, Guangzhou Academy of Fine Arts	
Itinerant Exhibition of China Fine Arts, Japan	1990
Joint Exhibition of Seven Hebei Artists, Shijiazhuang Workers' Culture Center	1986
6th National Exhibition of Arts, Jiangsu Provincial Art Museum, Nanjing	1984

申伟光简历

13

1986—2005
申伟光艺术 20 年

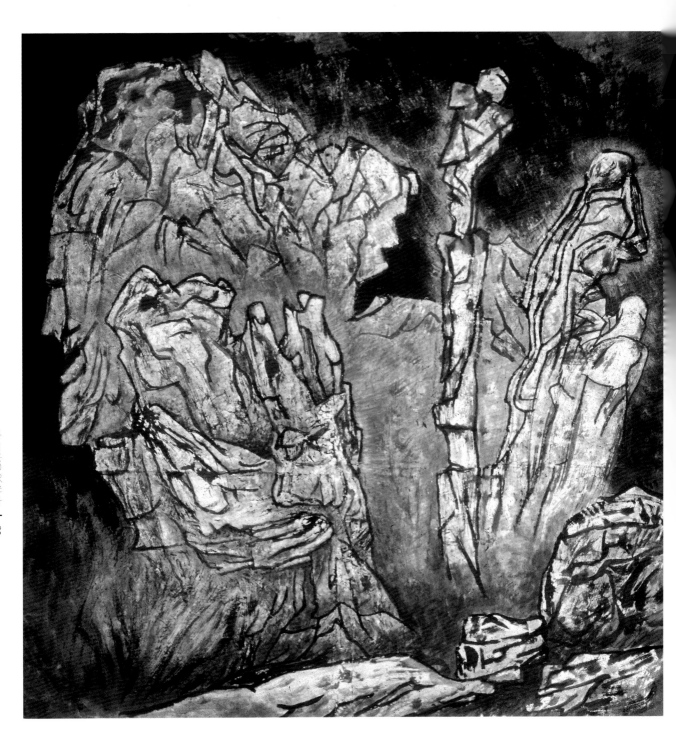

1986 作品 10 号

宣纸丙烯　135 × 135cm　1986 年

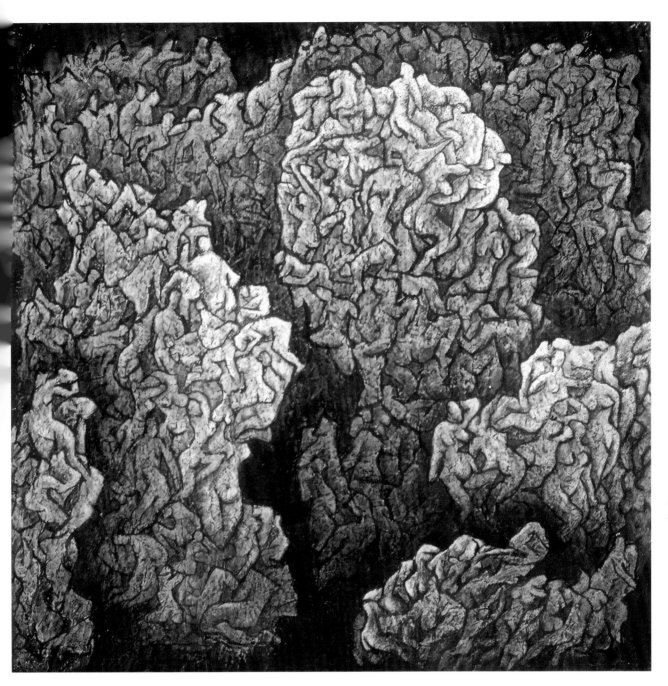

1987 作品 6 号

宣纸丙烯　100 × 100cm　1987 年

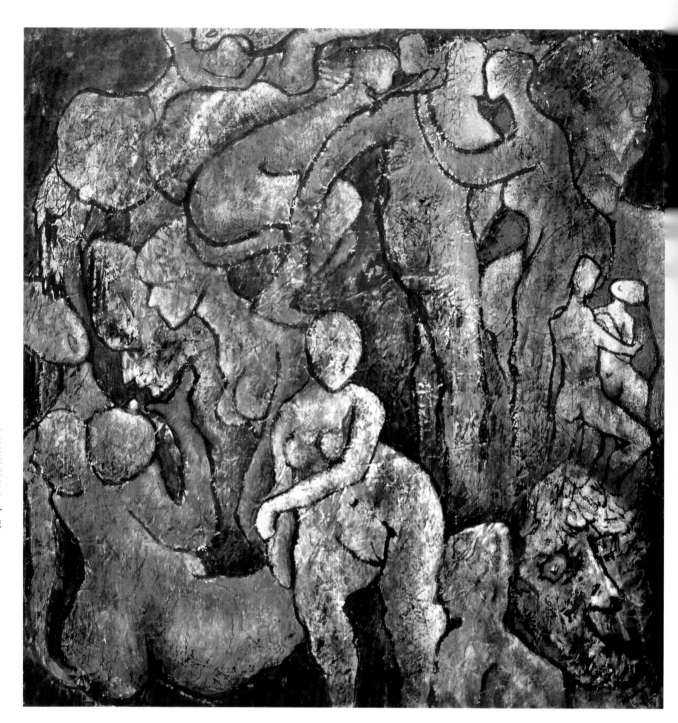

1987 作品 7 号

宣纸丙烯 100 × 100cm 1987 年

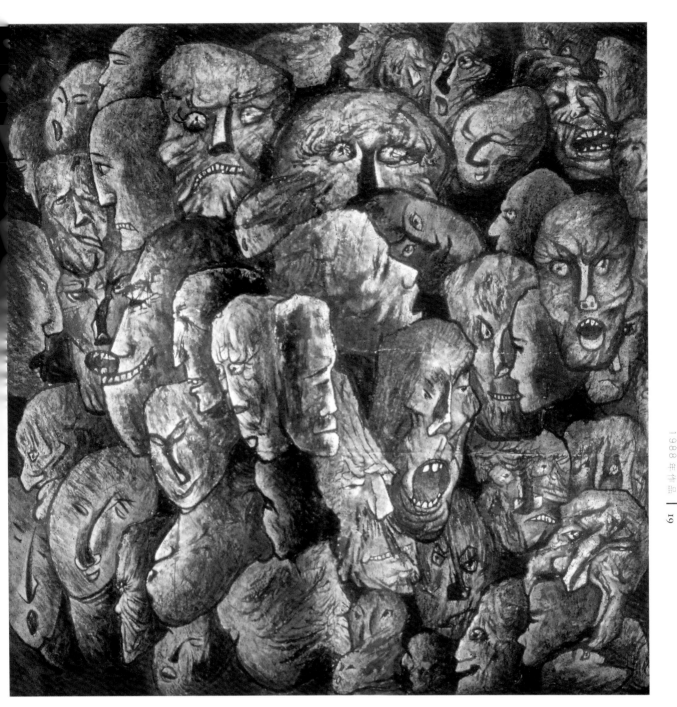

1988 作品 1 号

宣纸丙烯　135 × 135cm　1988 年

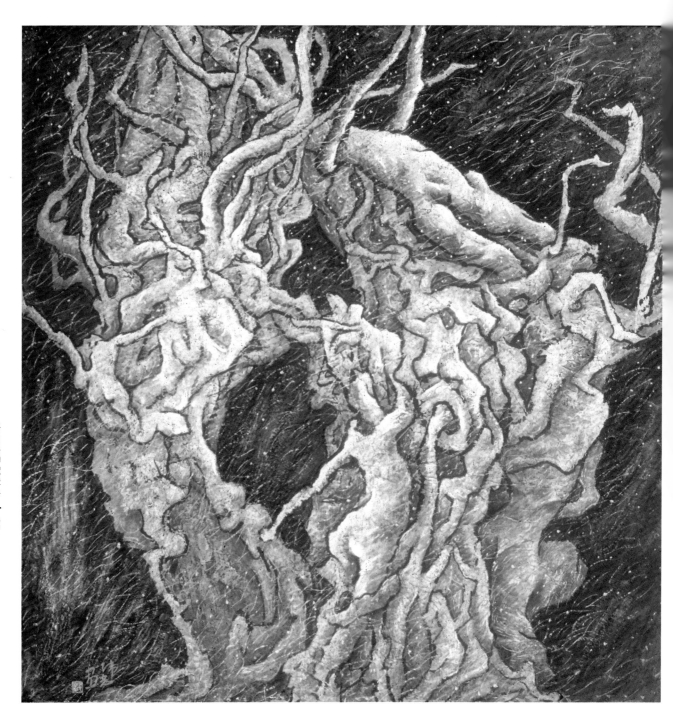

1988 作品 2 号

宣纸丙烯　135 × 135cm　1988 年

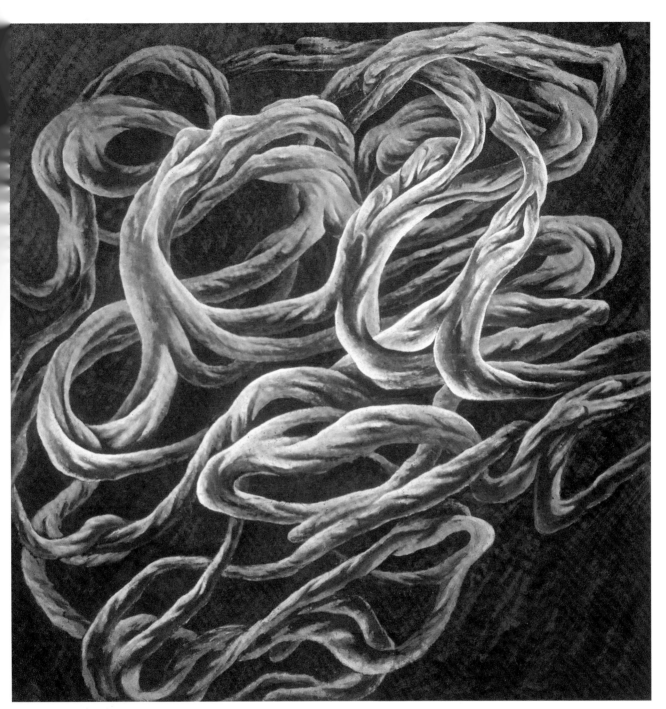

1988 作品 4 号

宣纸丙烯　135 × 135cm　1988 年

1988 作品 5 号

宣纸丙烯　135 × 135cm　1988 年

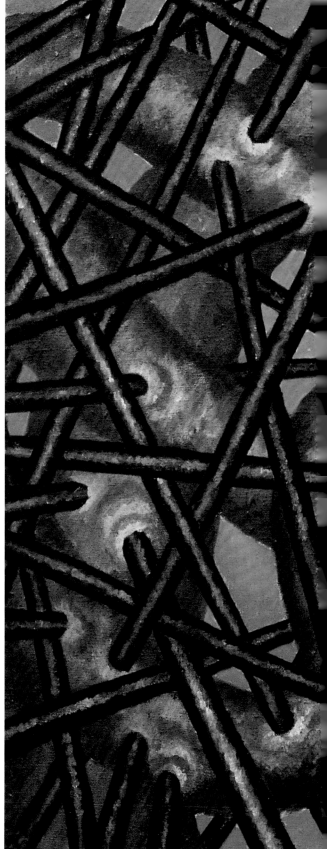

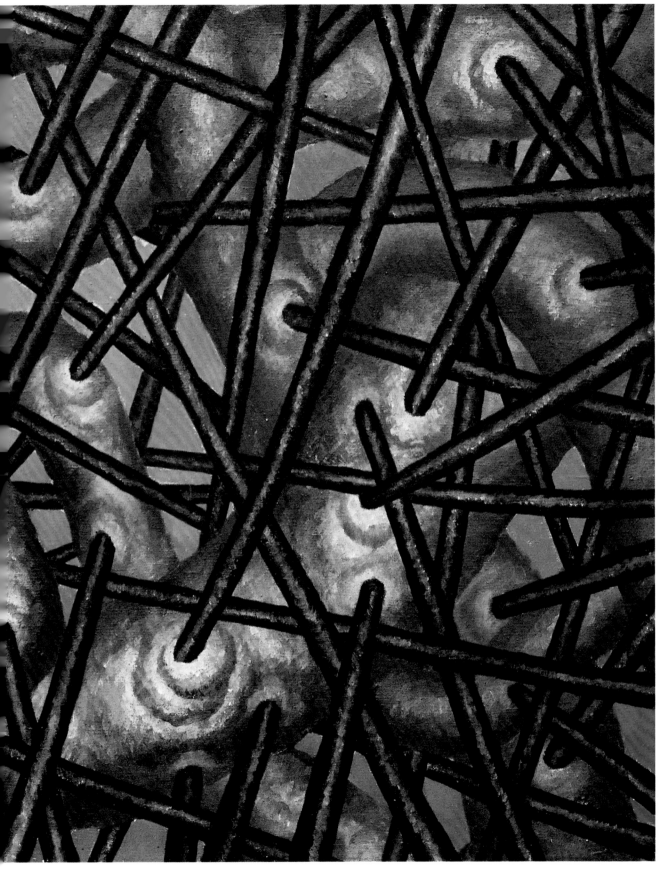

1991 作品 10 号

油画 90 × 70cm 1991 年

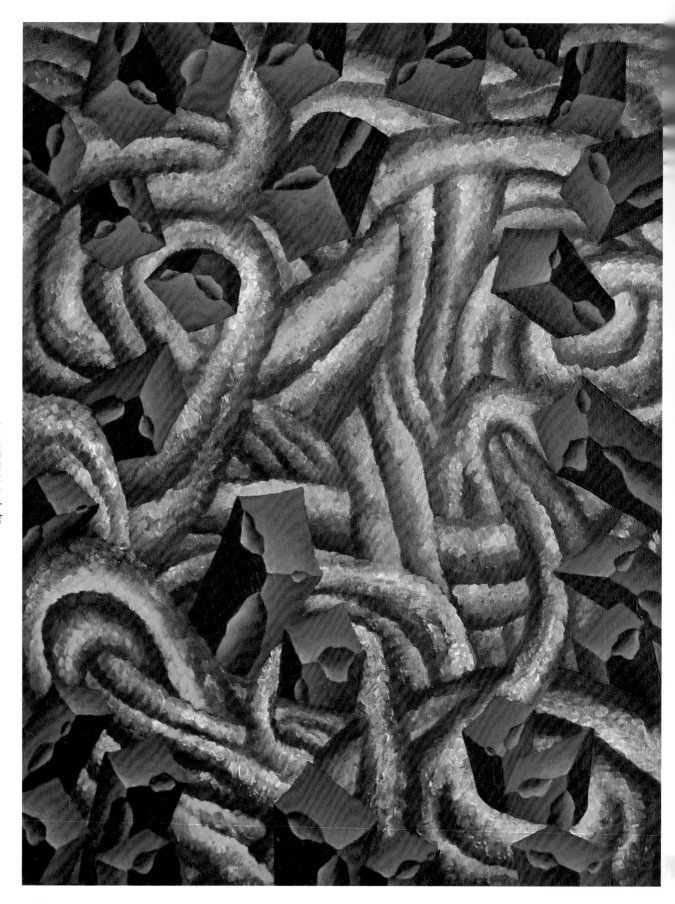

1991 作品 3 号

油画　90 × 70cm　1991 年

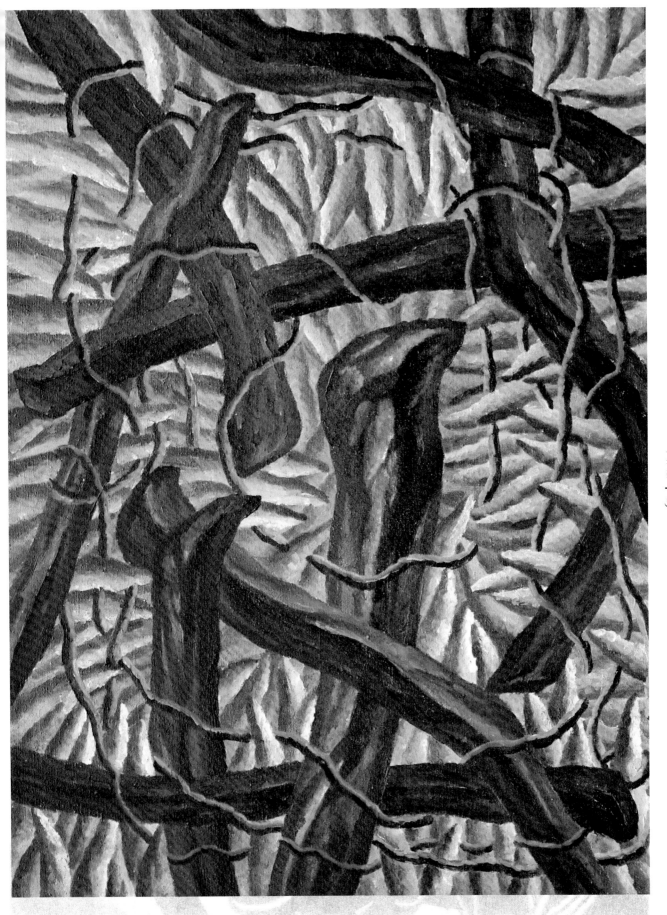

1991 作品 4 号

油画　90 × 70cm　1991 年

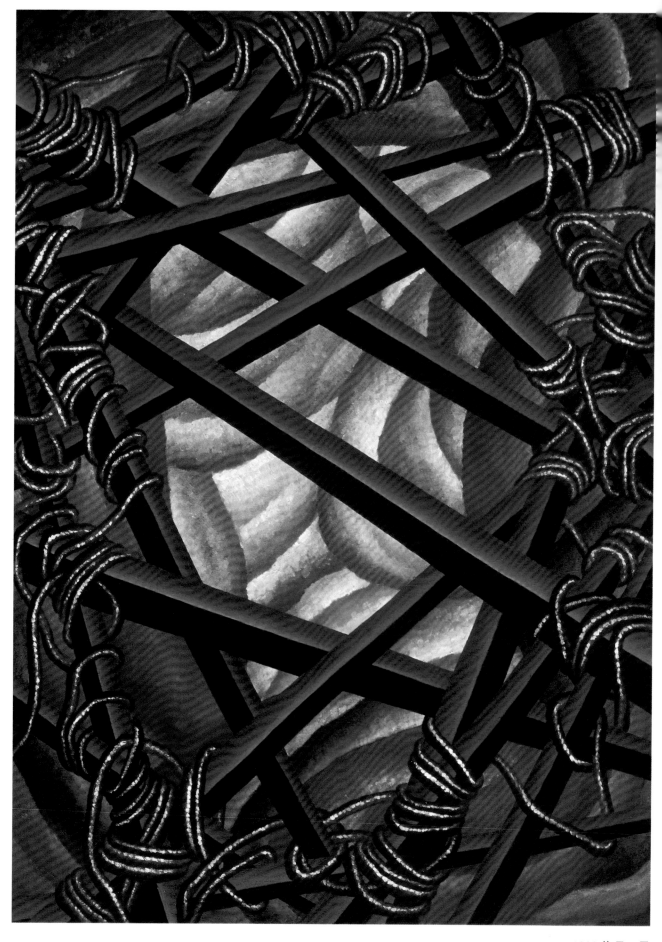

1992 作品 3 号

油画　130 × 92cm　1992 年

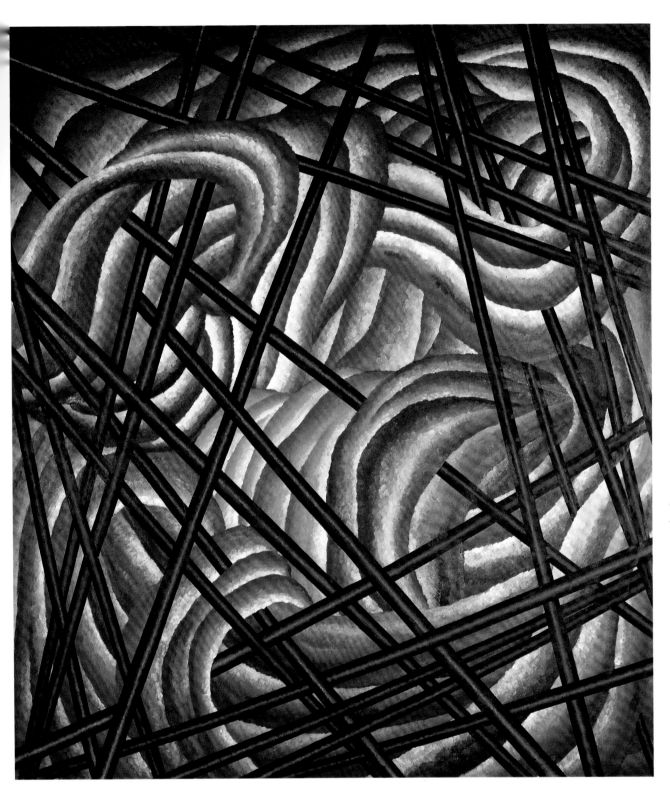

1992 作品 6 号

油画　180 × 160cm　1992 年

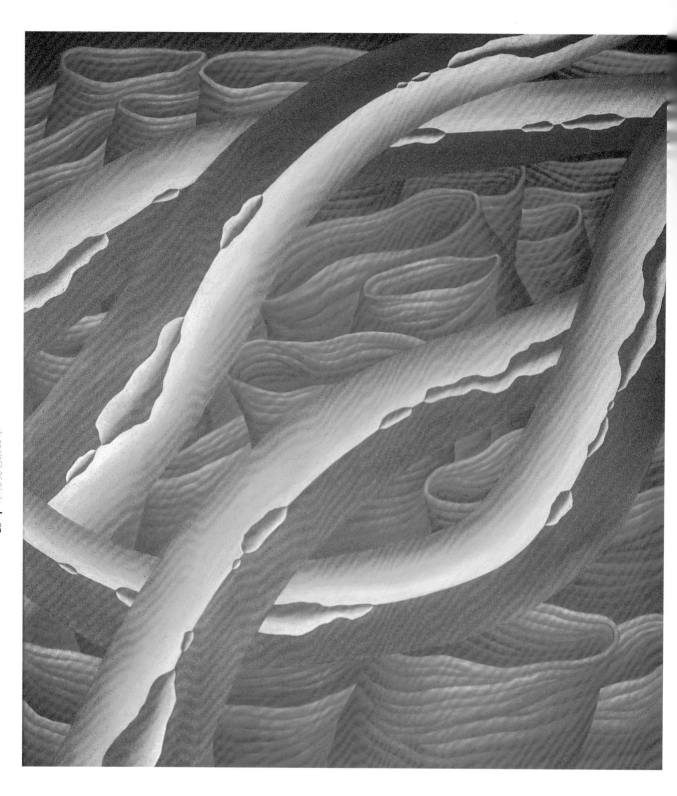

1992 作品 7 号

油画　180 × 160cm　1992 年

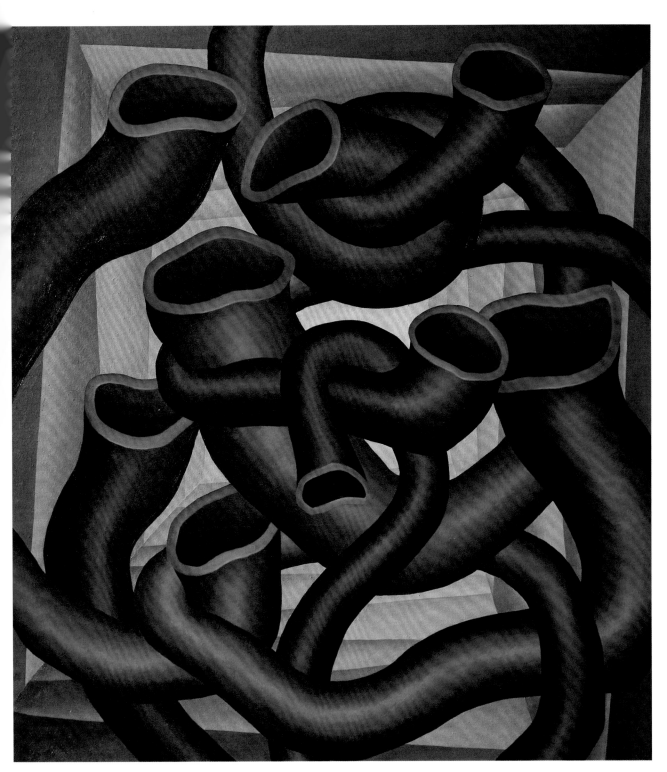

1993 作品 1 号

油画　180 × 160cm　1993 年

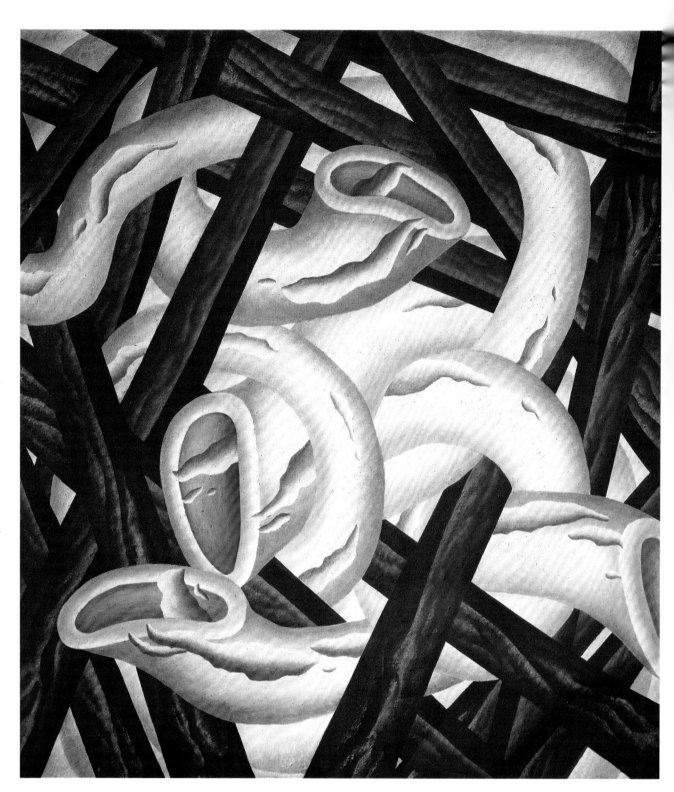

1993 作品 2 号

油画　180 × 160cm　1993 年

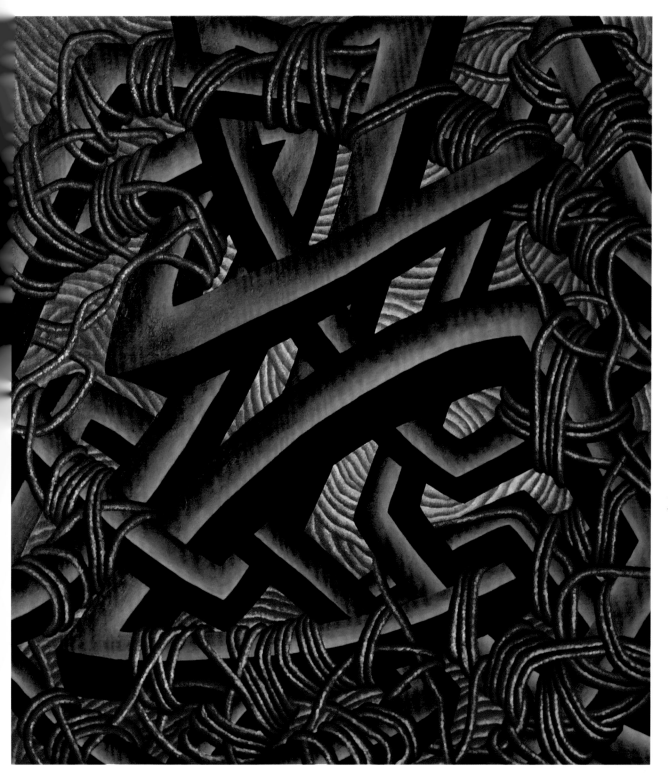

1993 作品 3 号

油画　180 × 160cm　1993 年

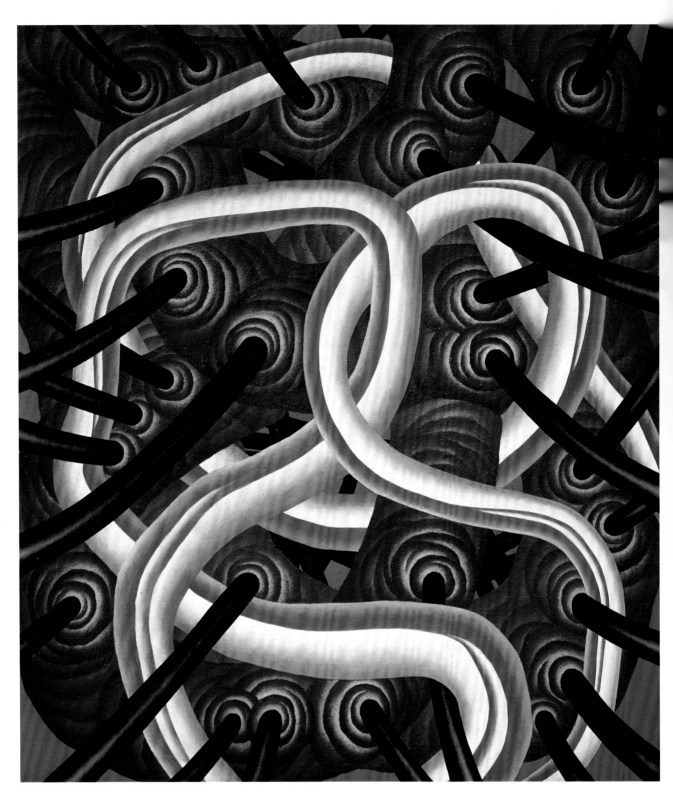

1993 作品 5 号

油画　180 × 160cm　1993 年

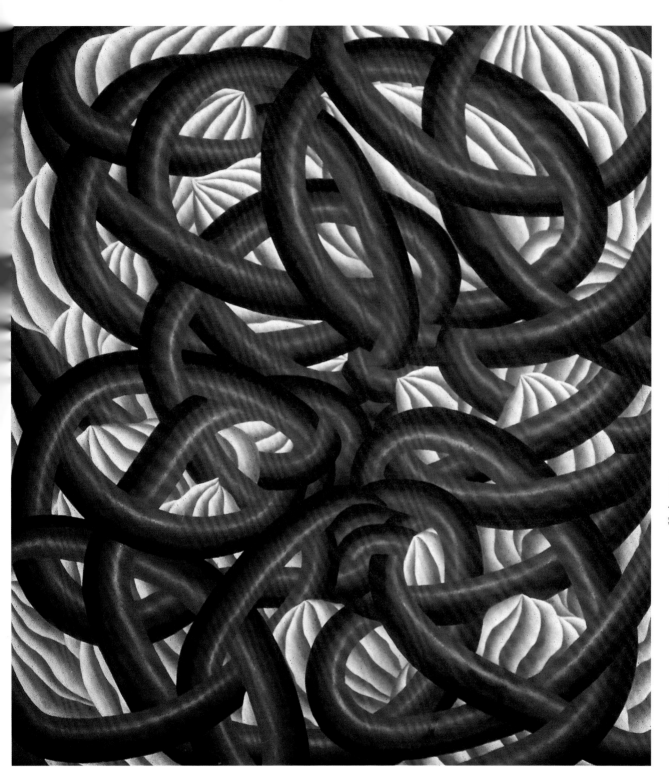

1994 作品 1 号
油画 180 × 160cm 1994 年

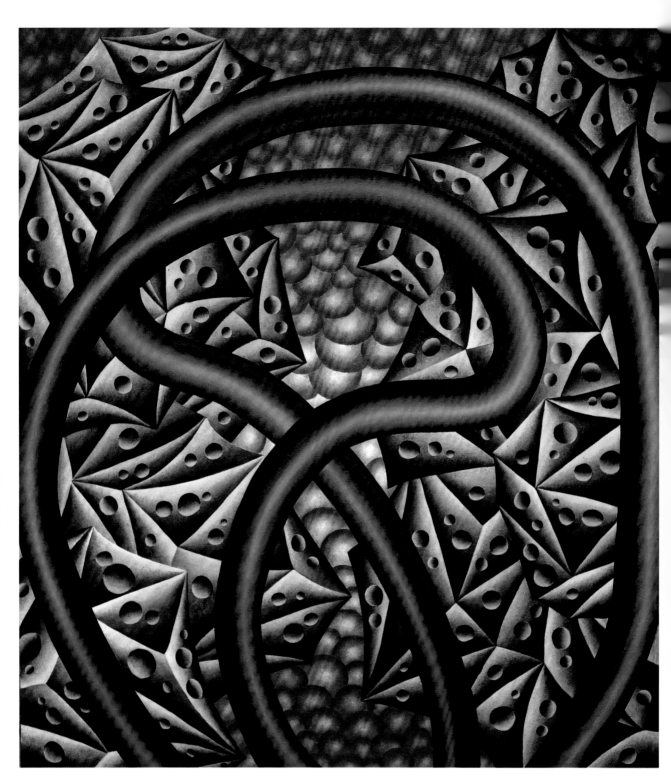

1994 作品 2 号

油画 180 × 160cm 1994 年

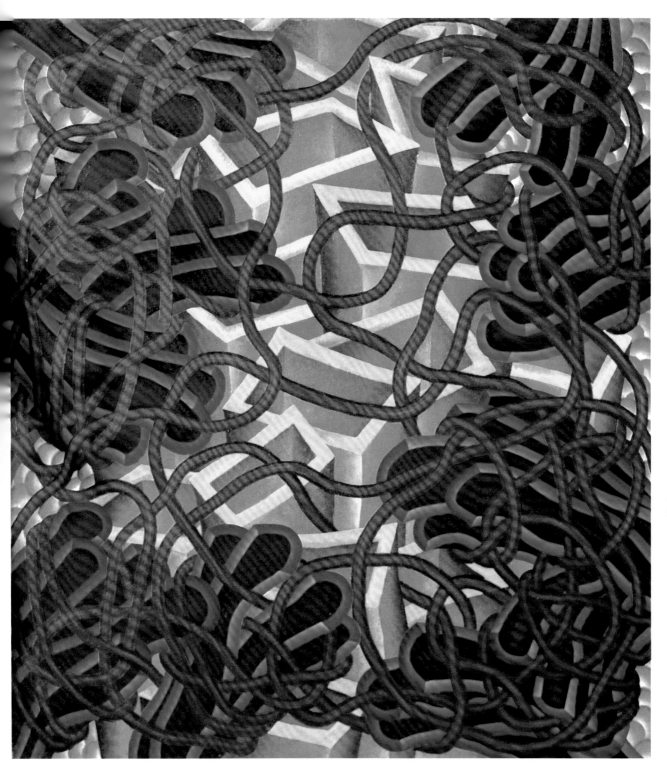

1994 作品 3 号

油画　180 × 160cm　1994 年

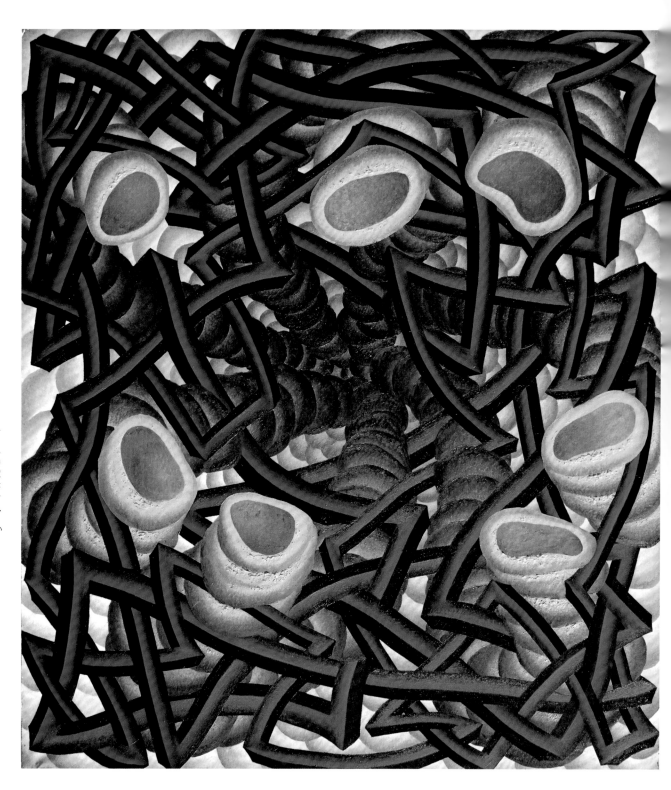

1994 作品 6 号

油画　180 × 160cm　1994 年

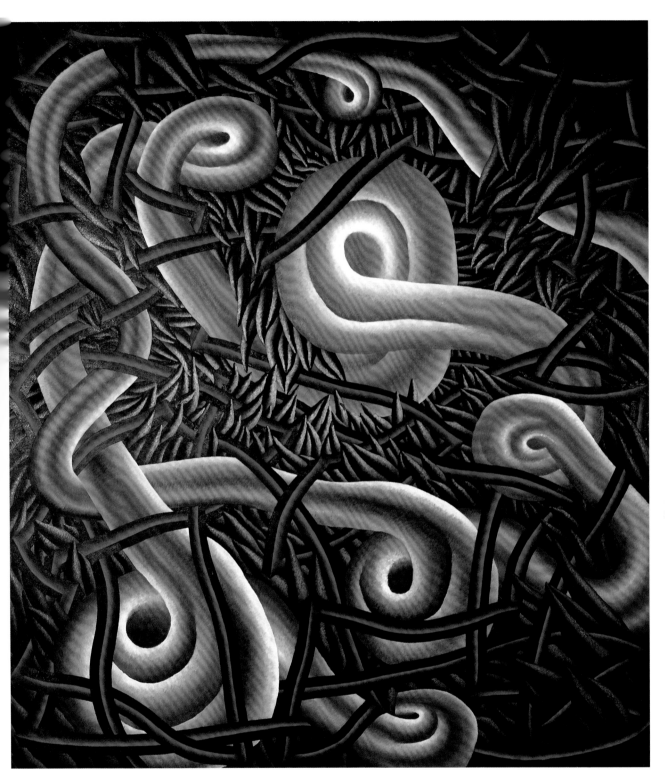

1994 作品 7 号

油画　180 × 160cm　1994 年

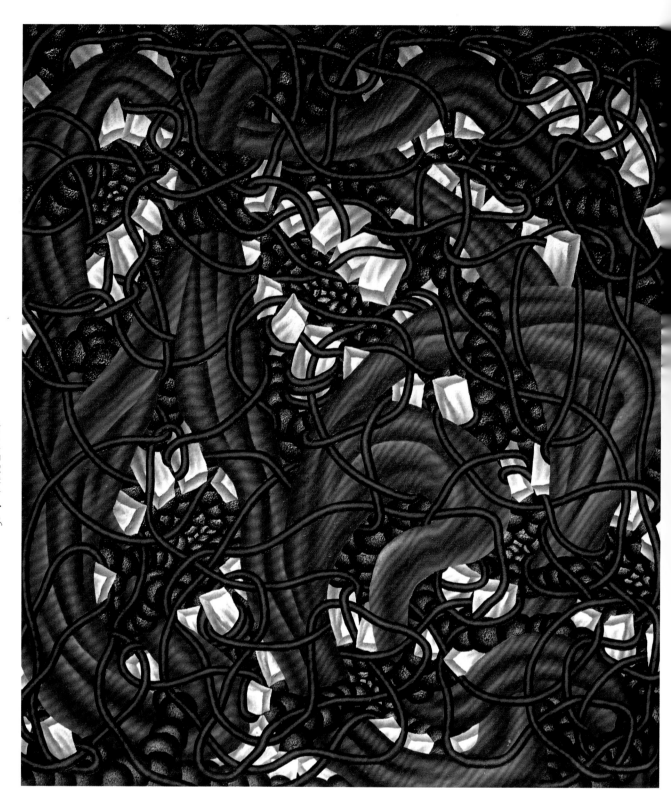

1995 作品 1 号

油画 180 × 160cm 1995 年

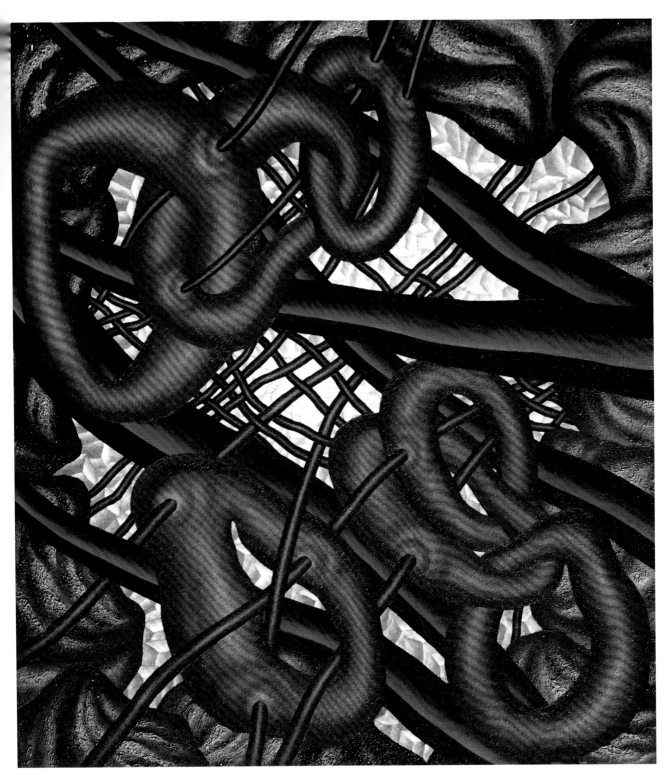

1995 作品 3 号

油画 180 × 160cm 1995 年

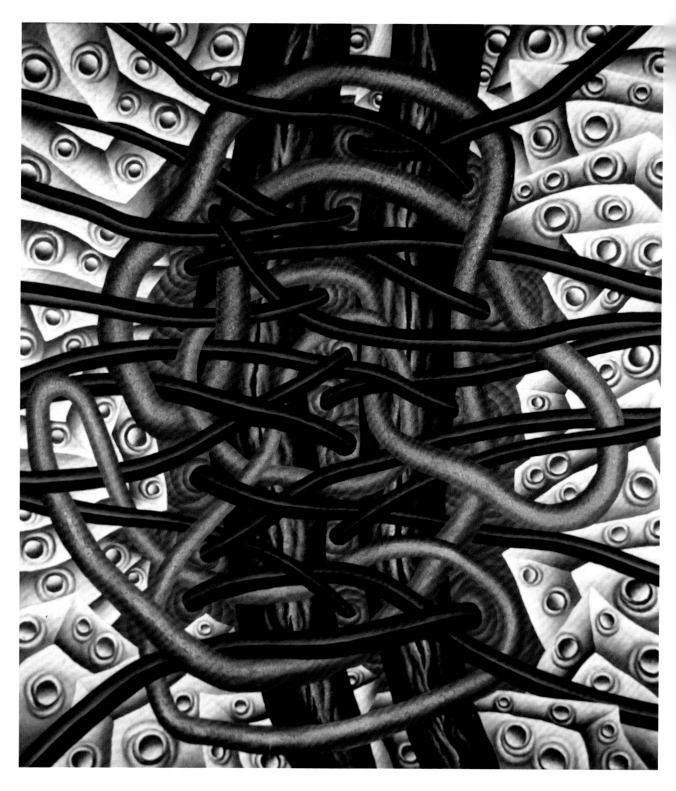

1995 作品 4 号

油画　180 × 160cm　1995 年

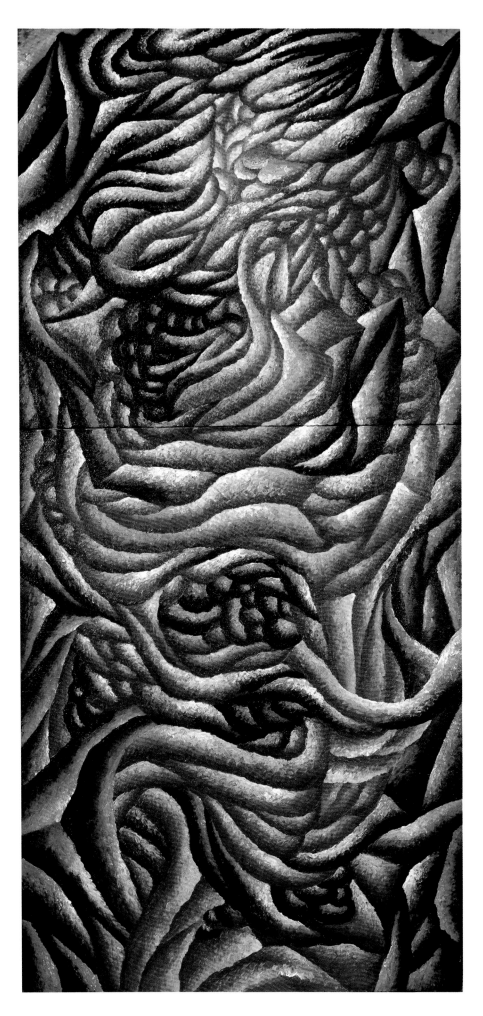

1996 作品 9 号

油画 170 × 80cm 1996 年

申伟光艺术20年

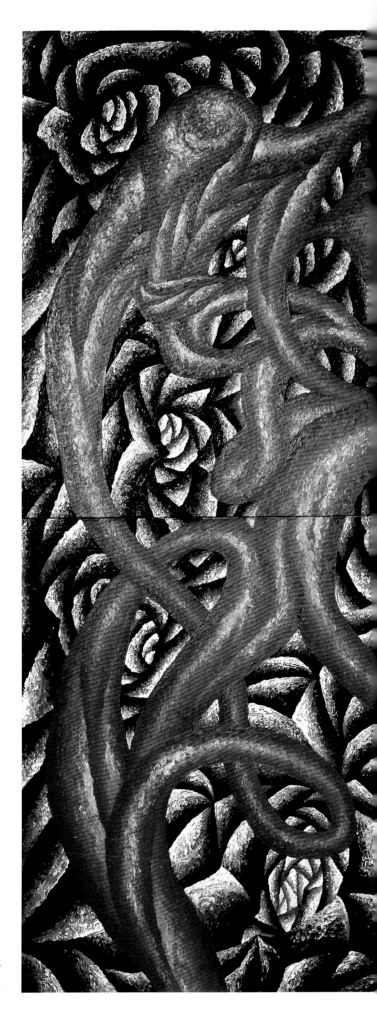

1997作品1号

油画　240 × 200cm　1997年

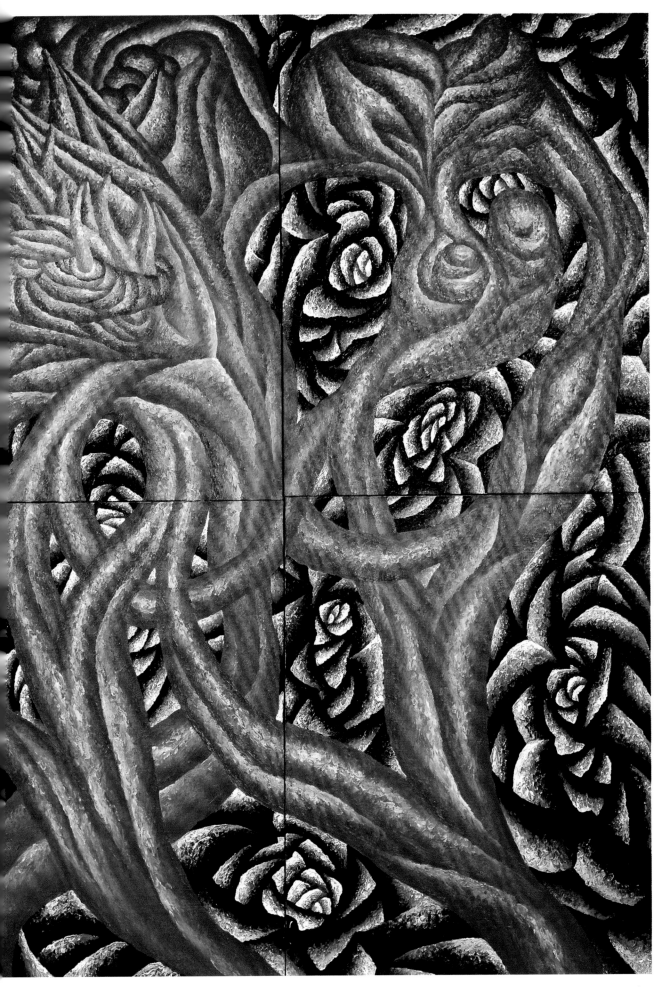

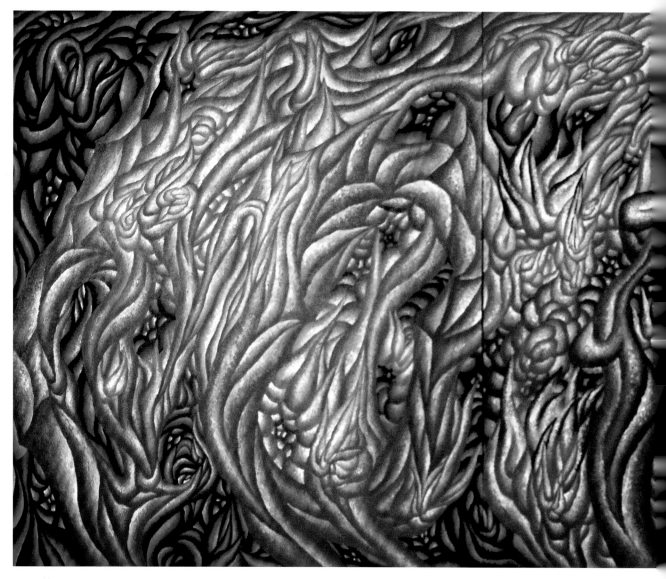

1997 作品 2 号

油画　480 × 180cm　1997 年

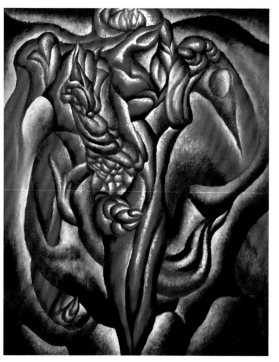

1998 作品 3 号

油画　100 × 80cm　1998 年

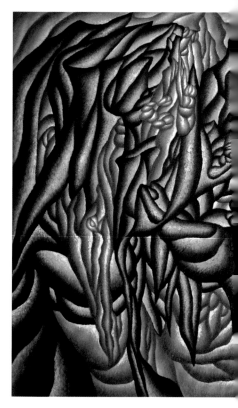

1998 作品 6 号

油画　480 × 180cm　1998 年

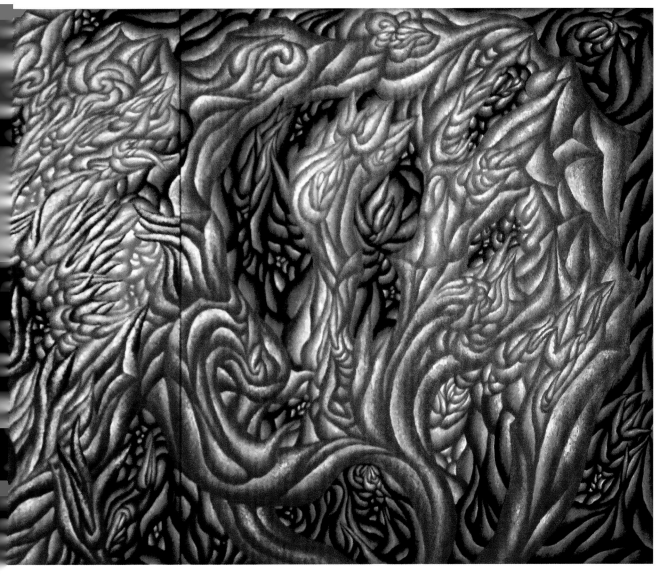

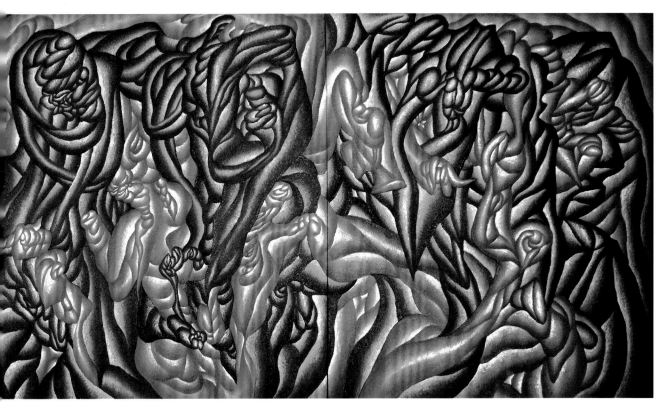

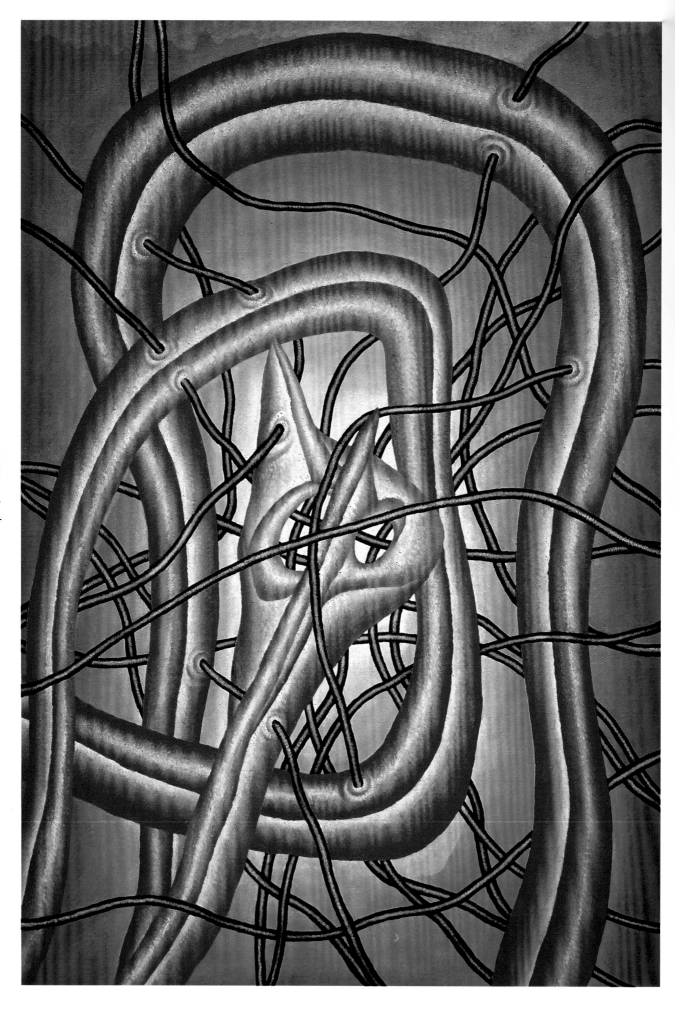

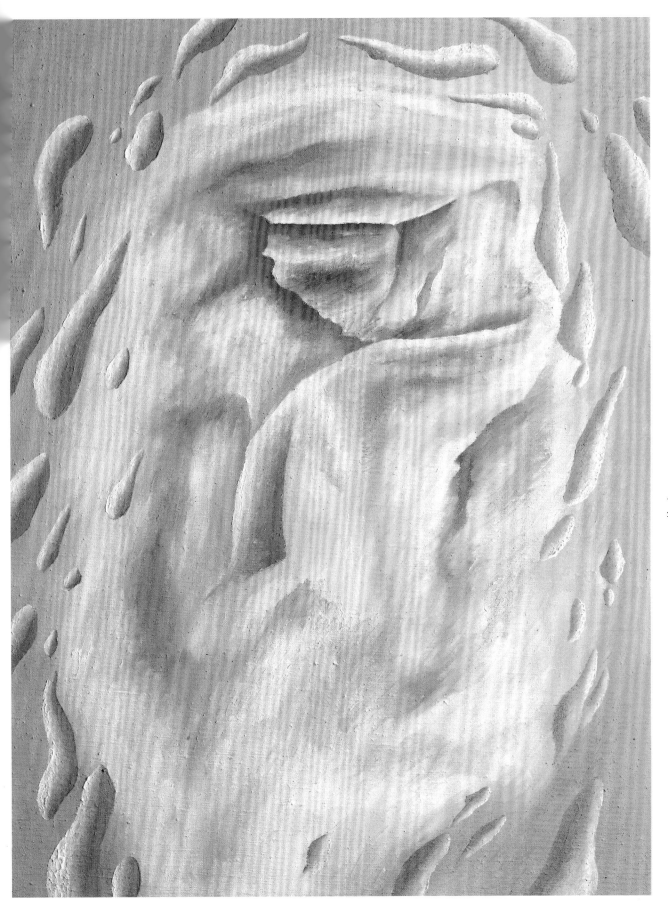

2000 作品 8 号（左页）

油画　260 × 175cm　2000 年

2000 作品 18 号

油画　92 × 70cm　2000 年

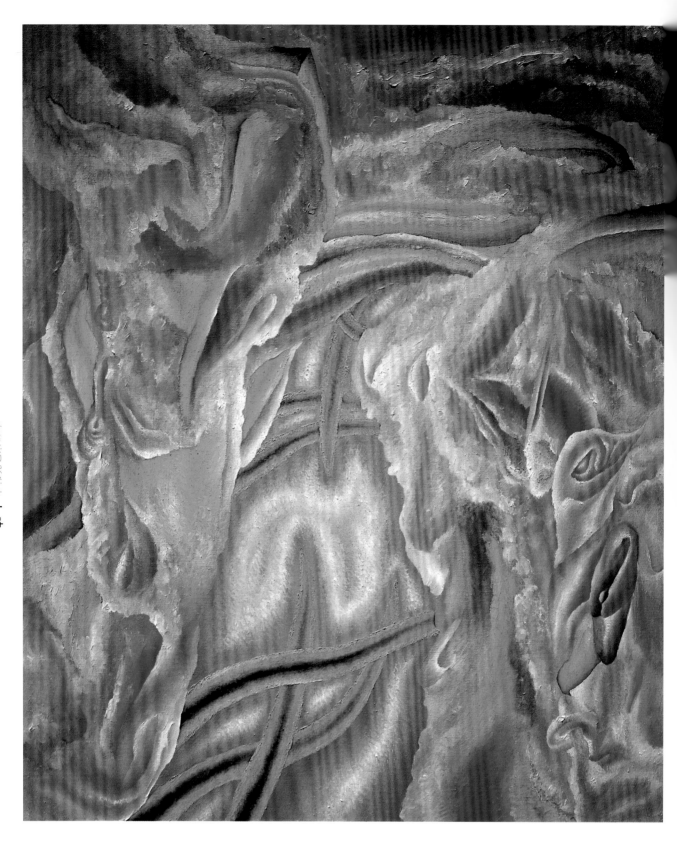

2001 作品 5 号

油画 170×140cm 2001年

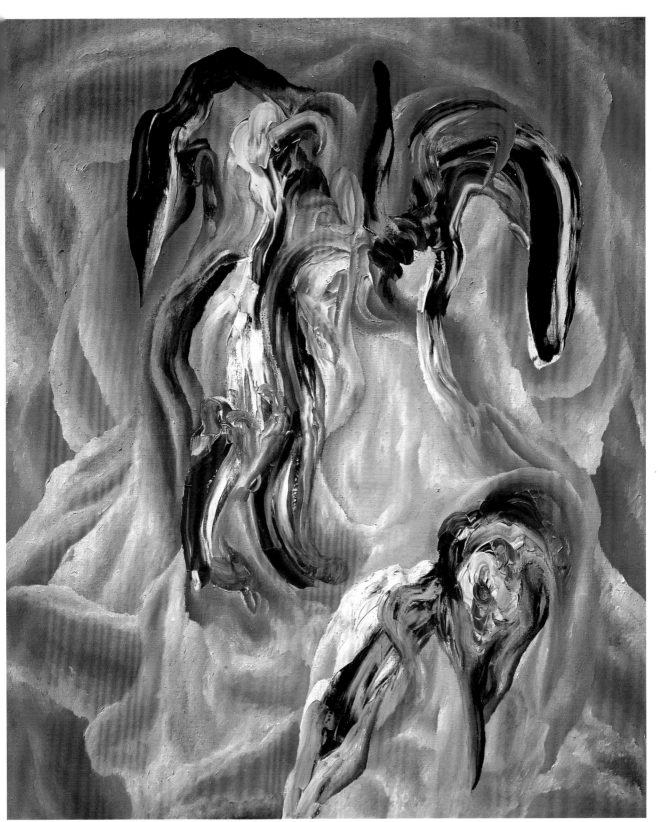

2001 作品 6 号

油画　170 × 140cm　2001 年

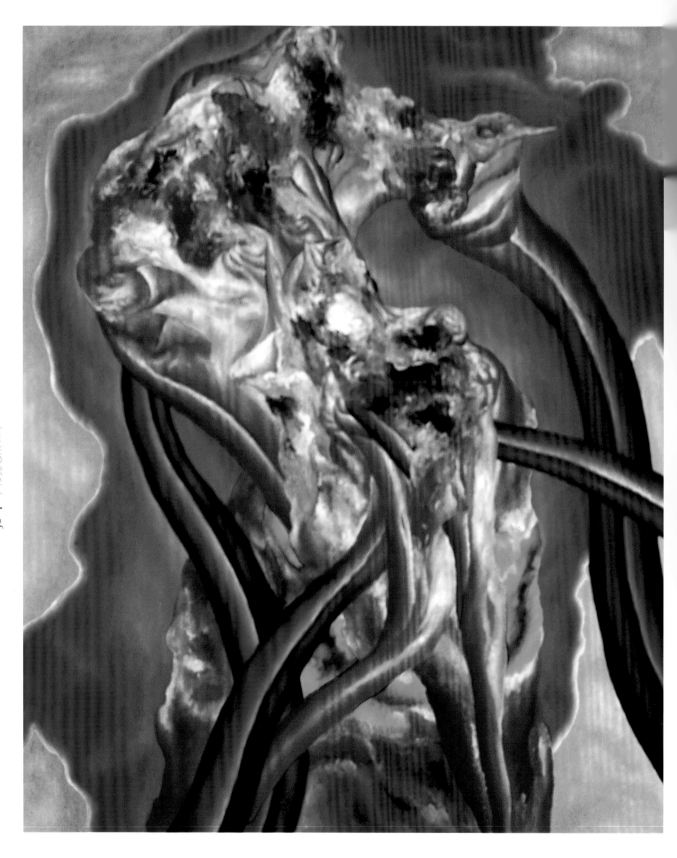

2001 作品 9 号

油画　170 × 140cm　2001 年

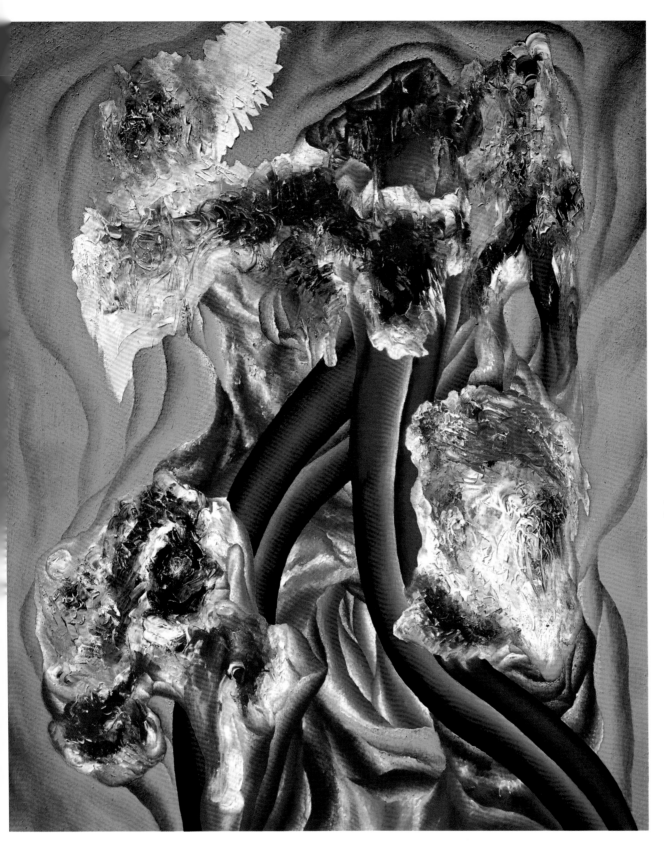

2001 作品 10 号

油画 170 × 140cm 2001 年

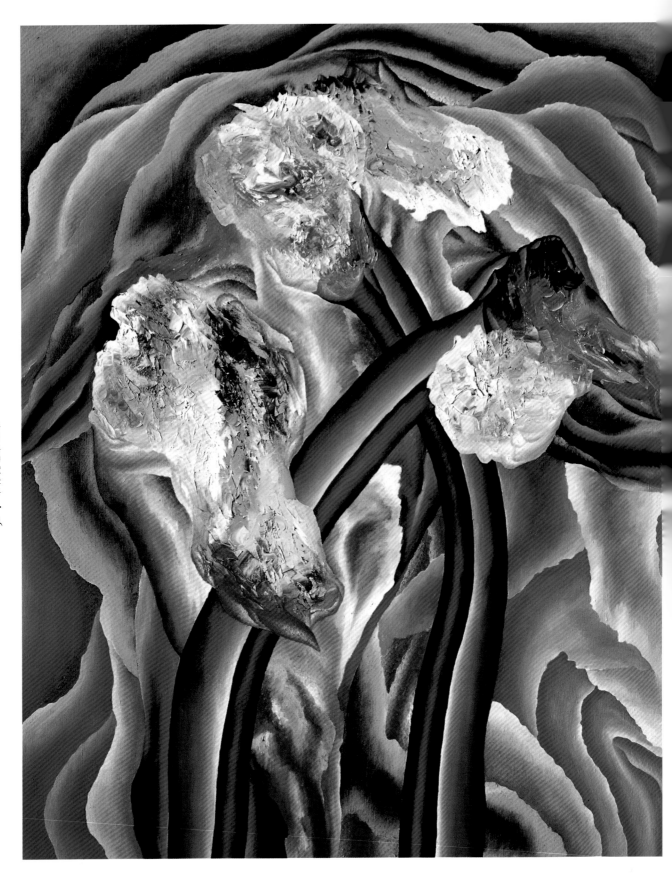

2001 作品 11 号

油画　170 × 140cm　2001 年

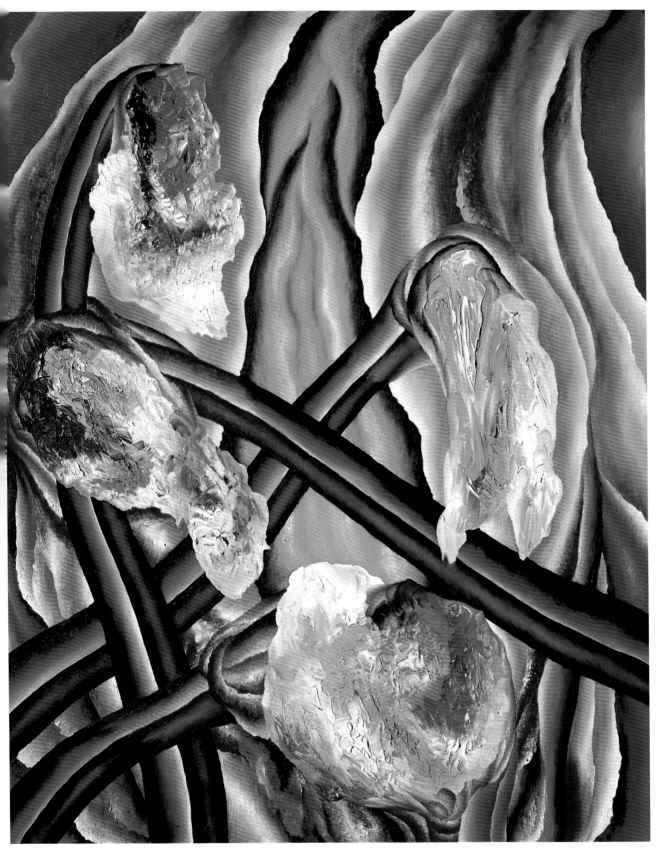

2001 作品 12 号

油画 170 × 140cm 2001 年

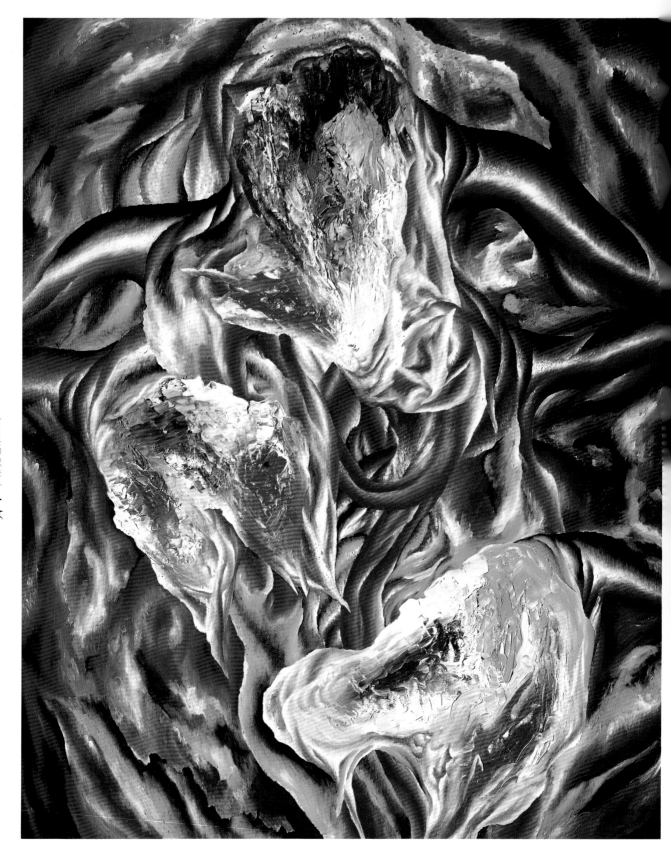

2001 作品 13 号

油画　170 × 140cm　2001 年

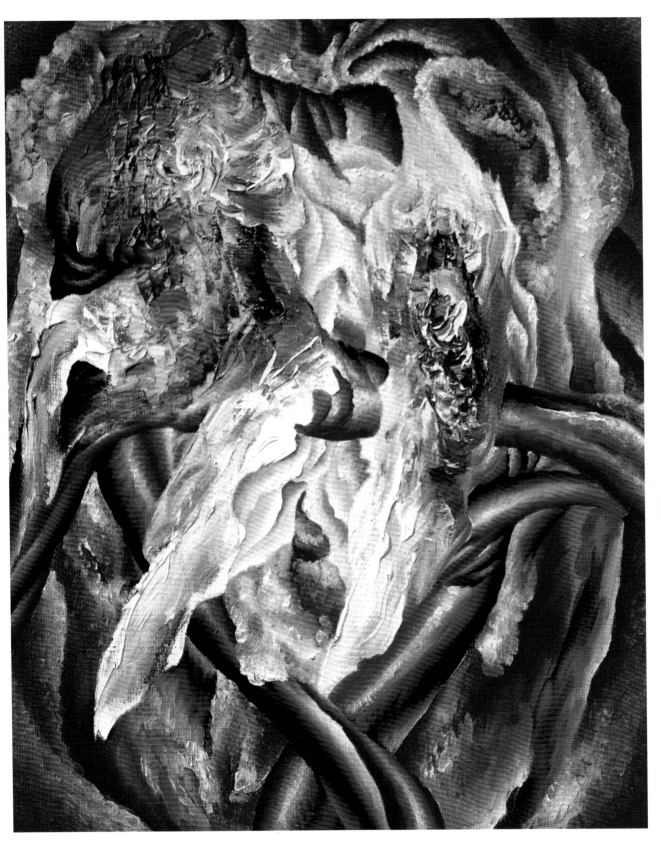

2001 作品 24 号

油画　64 × 52cm　2001 年

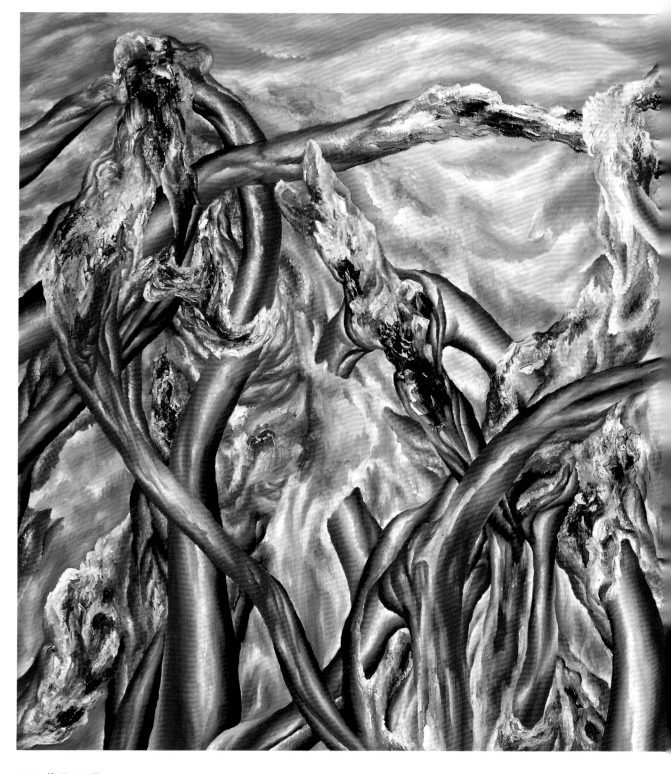

2001 作品 26 号

油画　260 × 175cm　2001 年

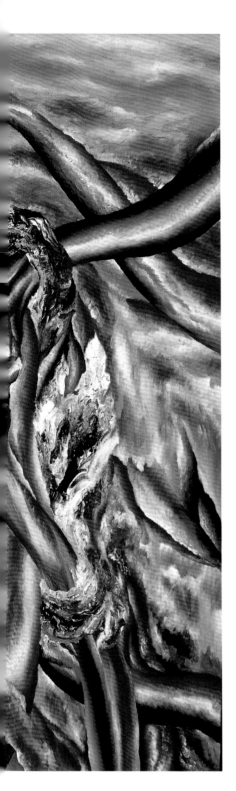

2001 作品 27 号

油画　260 × 175cm　2001 年

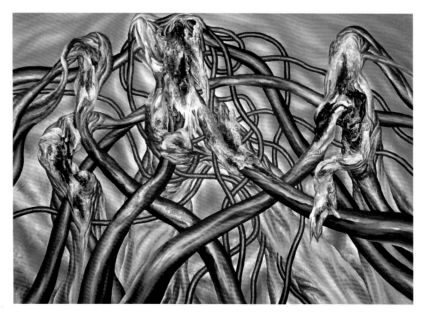

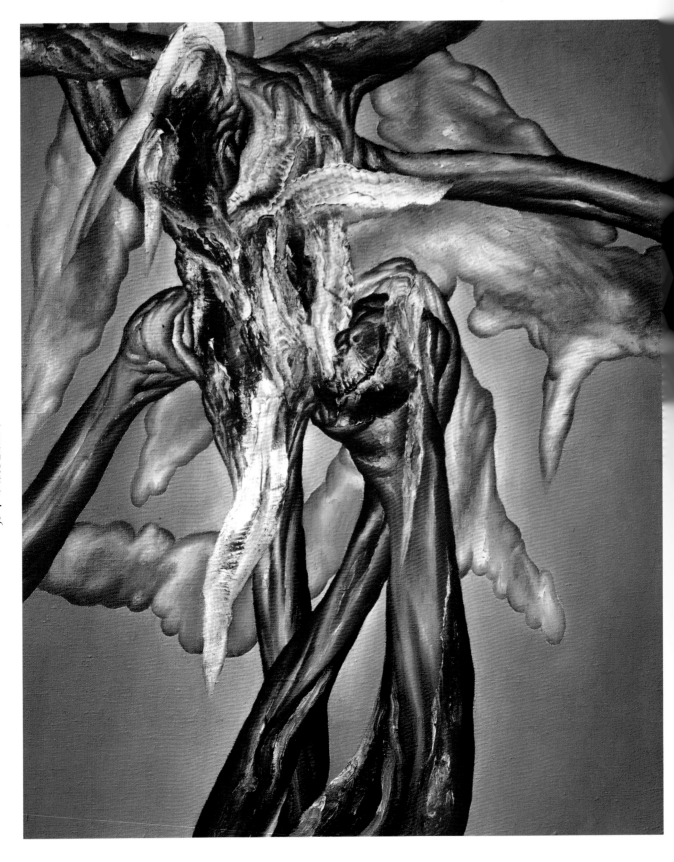

2002 作品 4 号

油画　100 × 80cm　2002 年

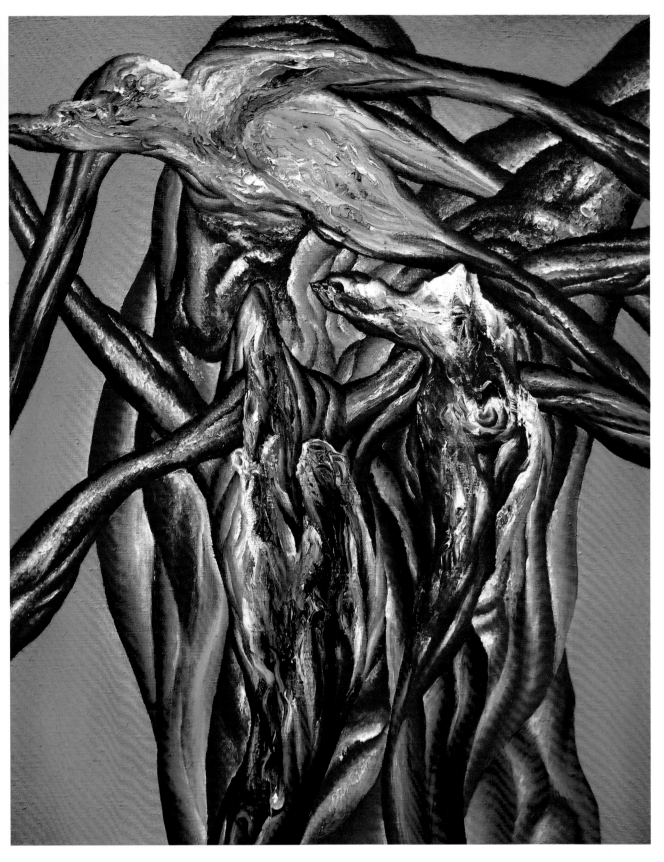

2002 作品 9 号

油画 100 × 80cm 2002 年

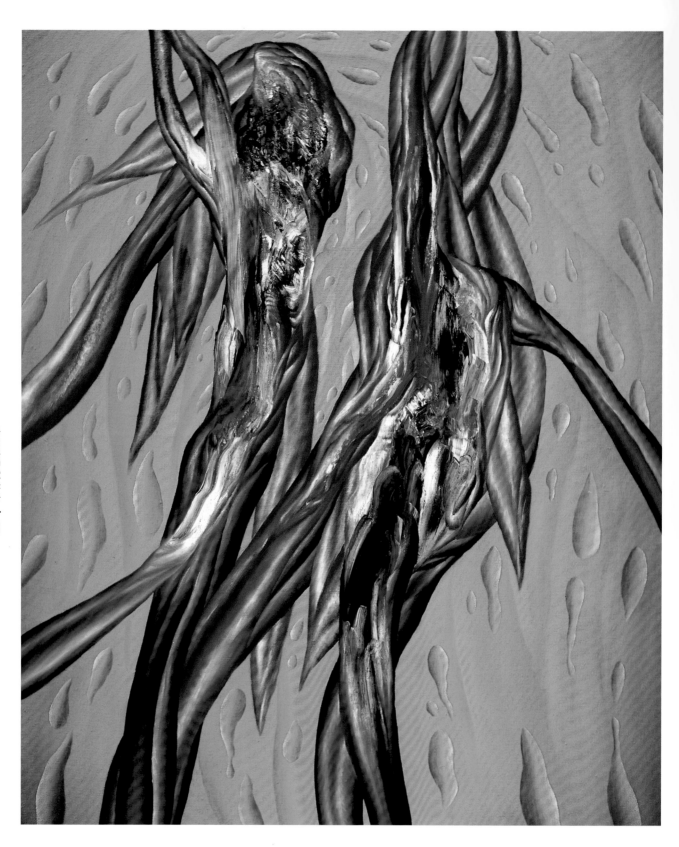

2002 作品 11 号

油画　170 × 140cm　2002 年

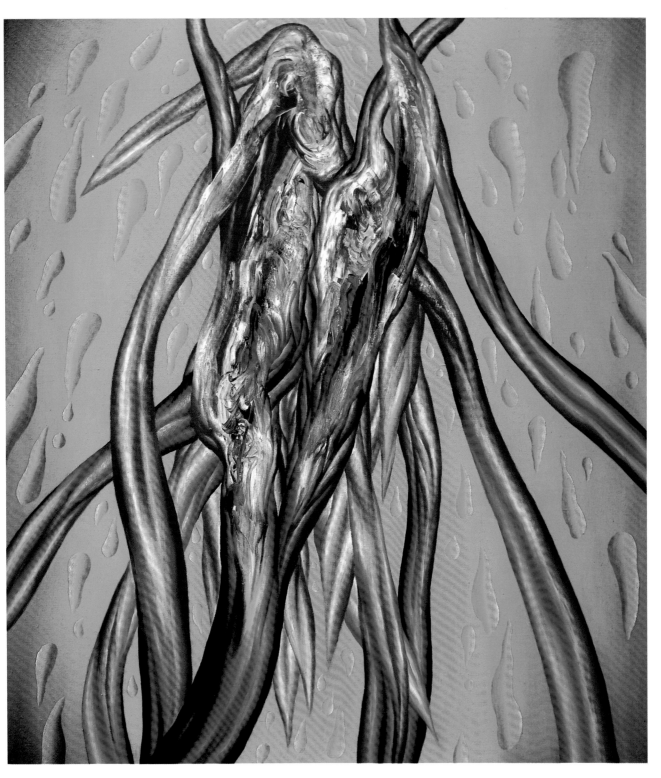

2002 作品 12 号

油画　180 × 160cm　2002 年

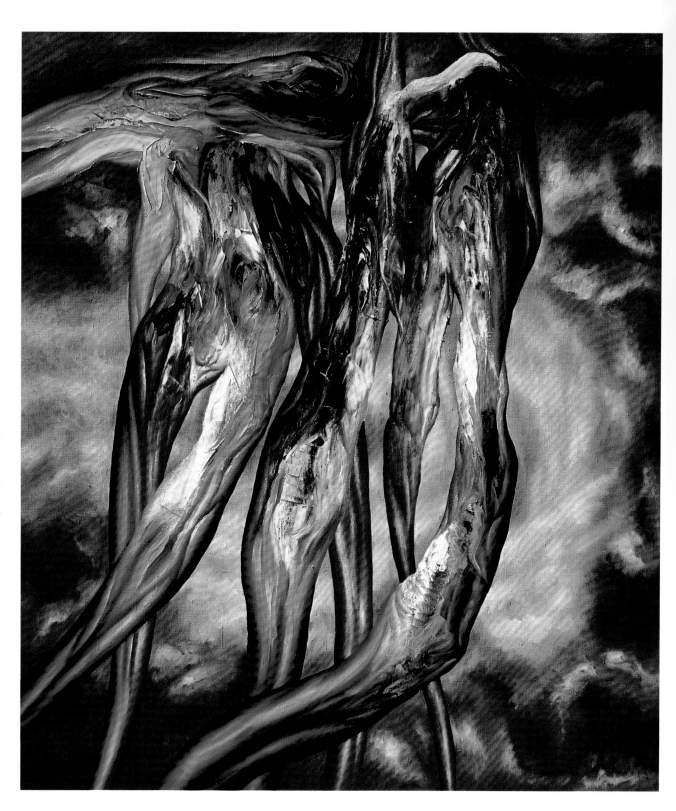

2002 作品 14 号

油画　180×160cm　2002 年

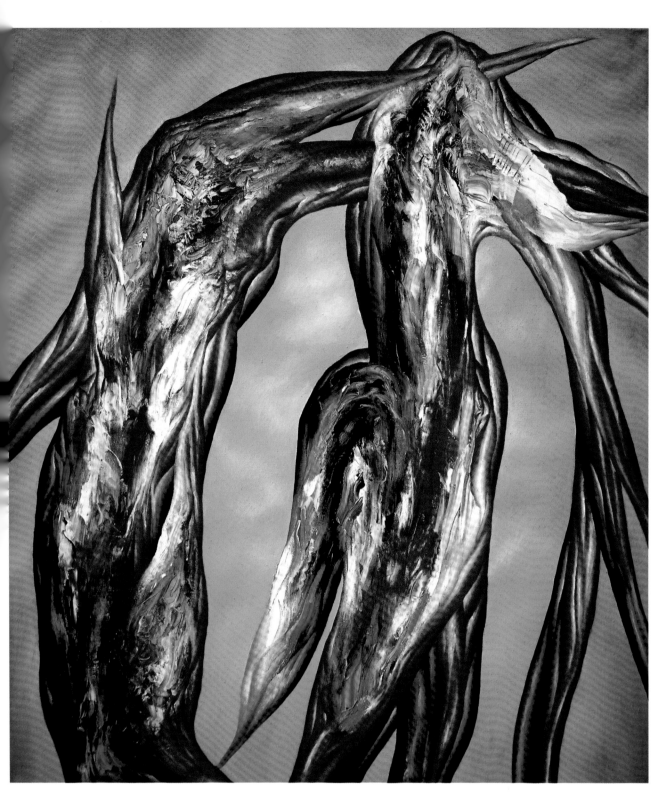

2002 作品 26 号

油画　180 × 160cm　2002 年

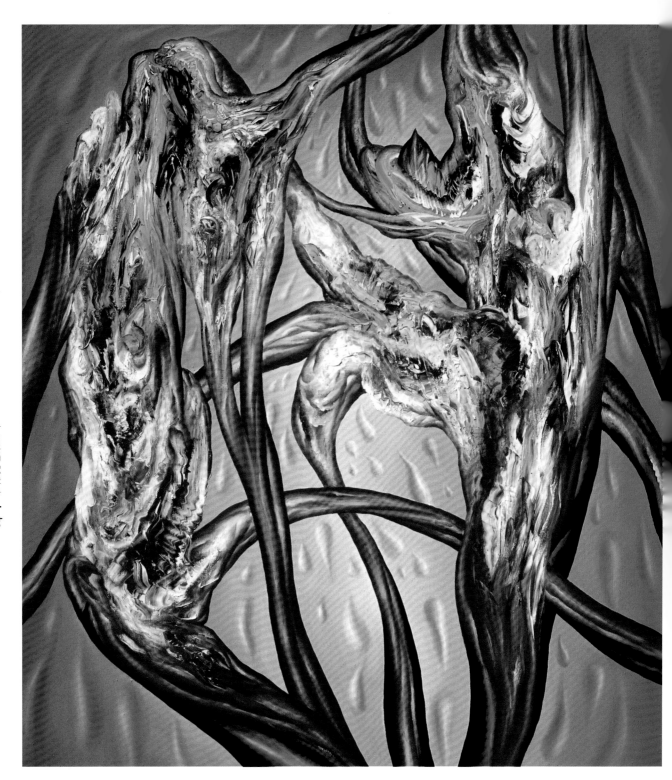

2002 作品 28 号

油画　180 × 160cm　2002 年

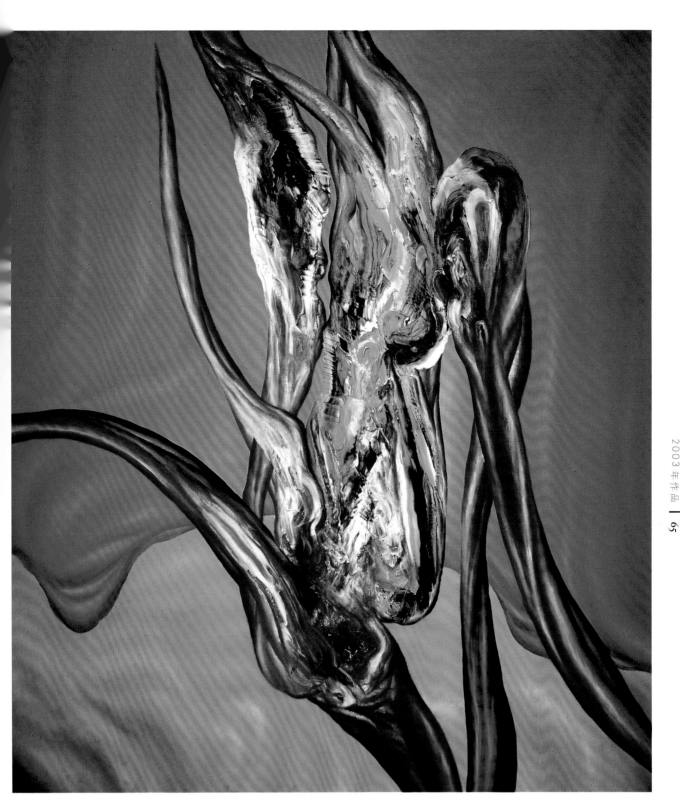

2003 作品 1 号

油画　180 × 160cm　2003 年

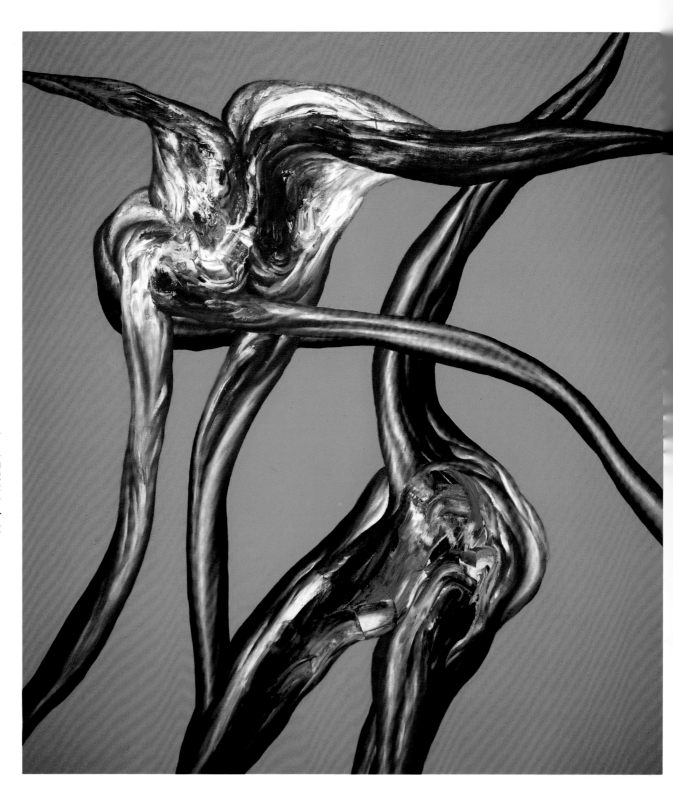

2003 作品 2 号

油画　180 × 160cm　2003 年

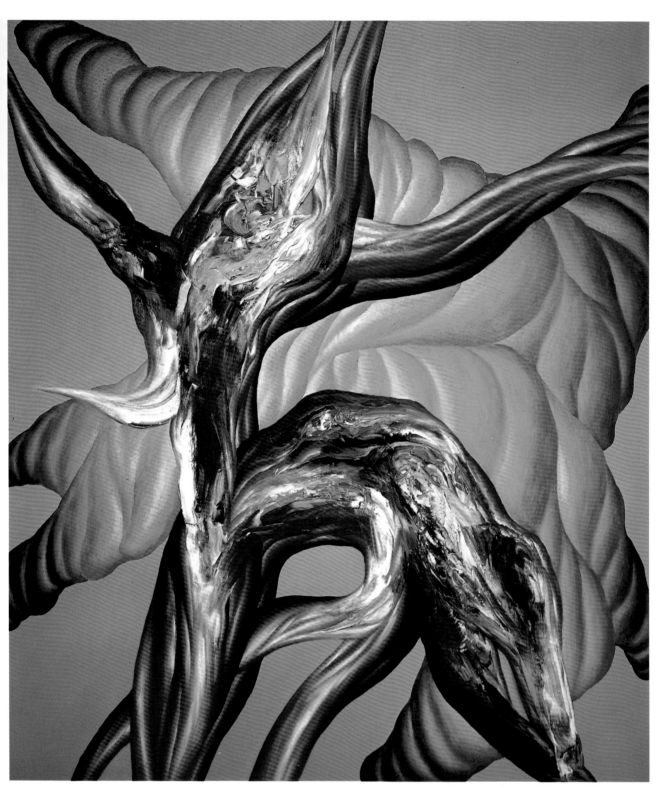

2003 作品 3 号

油画　180 × 160cm　2003 年

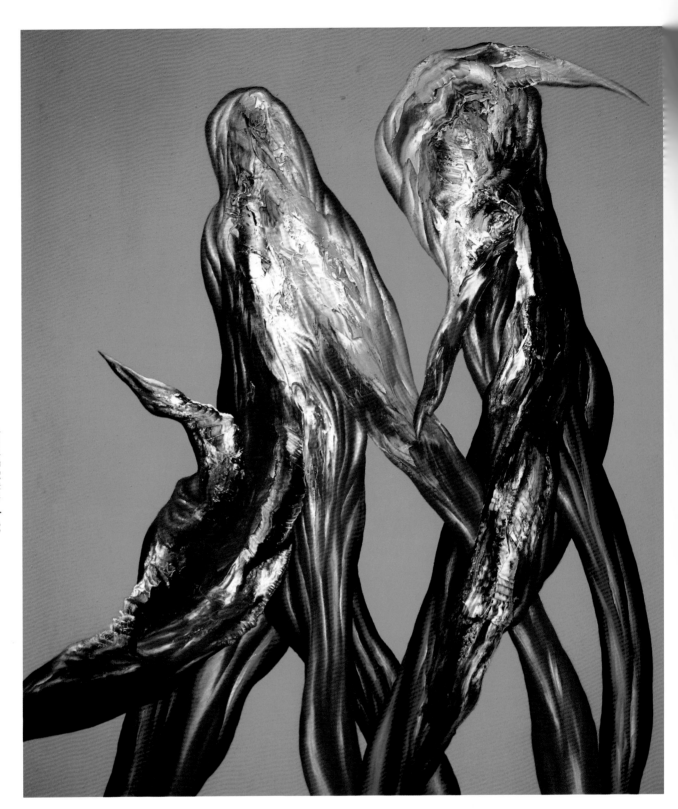

2003 作品 5 号

油画　180 × 160cm　2003 年

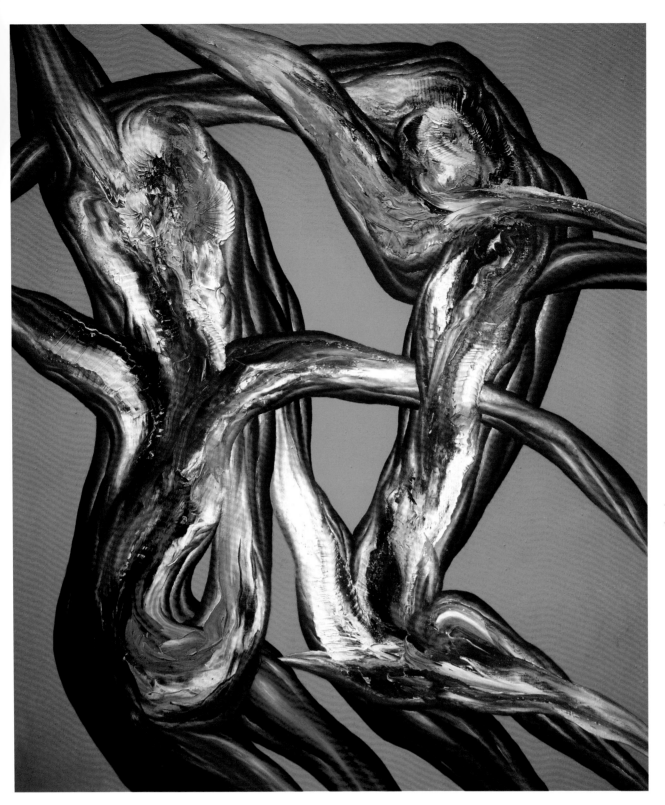

2003 作品 6 号

油画　180 × 160cm　2003 年

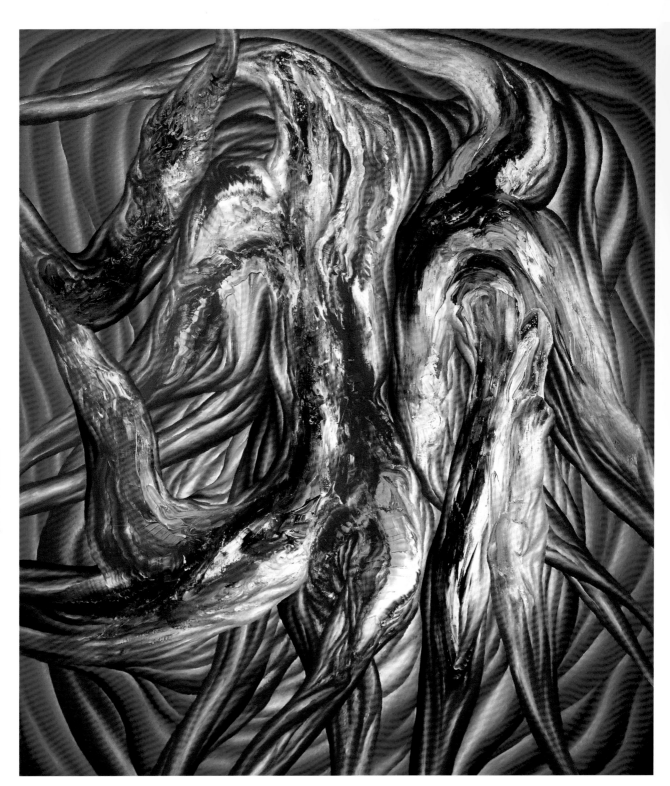

2003 作品 7 号

油画　180 × 160cm　2003 年

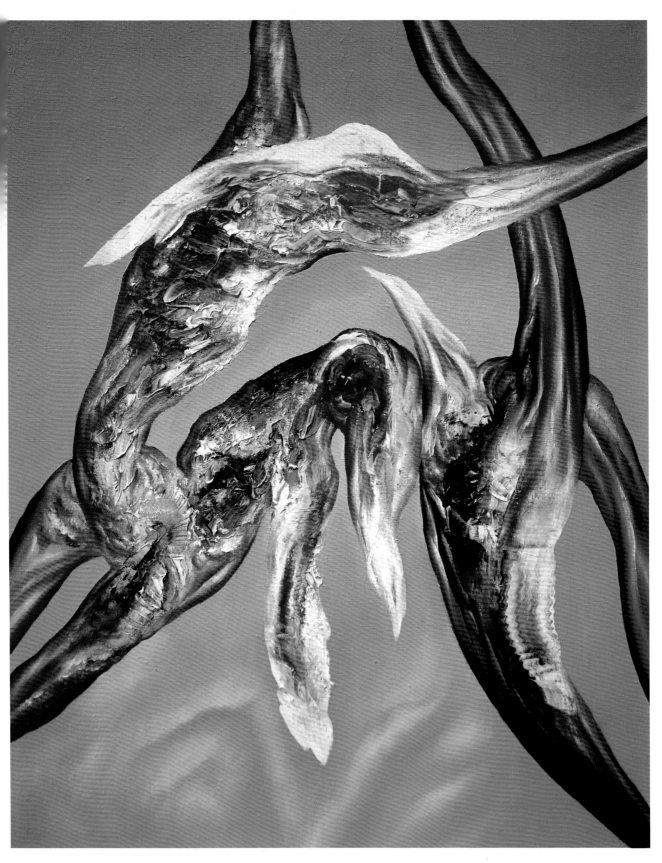

2003 作品 12 号

油画　100 × 80cm　2003 年

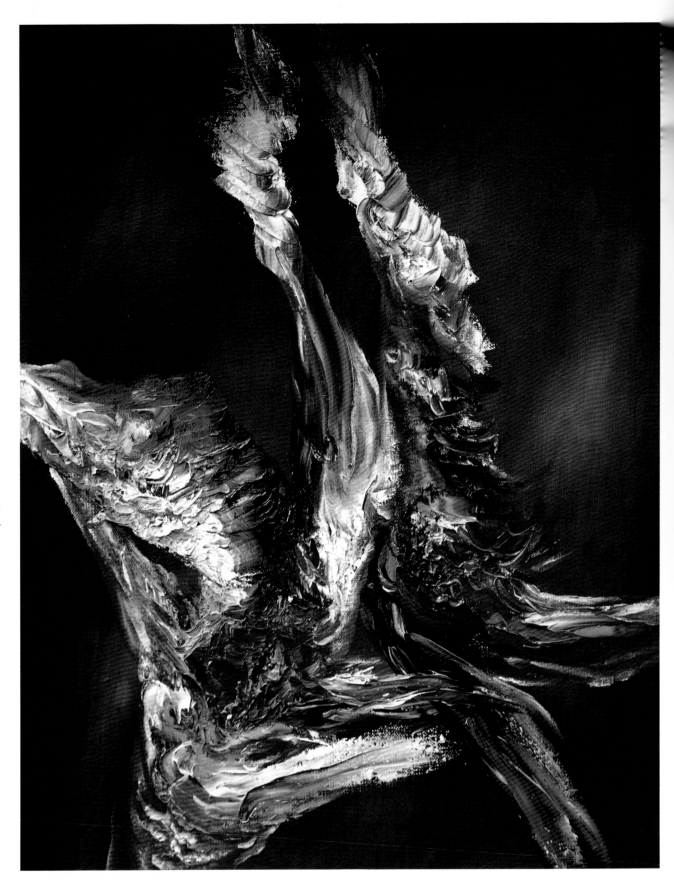

2003 作品 18 号

油画　64 × 52cm　2003 年

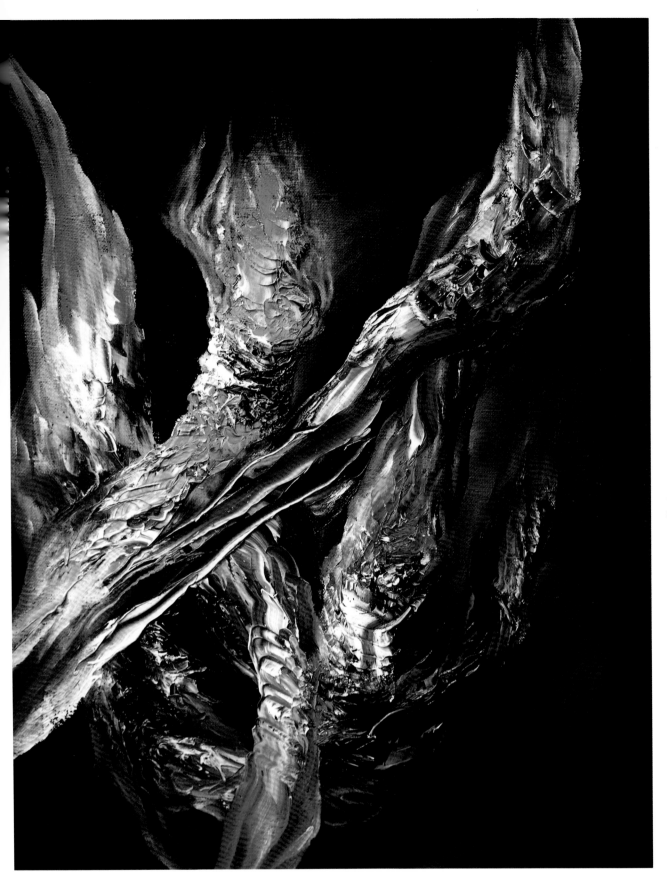

2003 作品 19 号

油画　64 × 52cm　2003 年

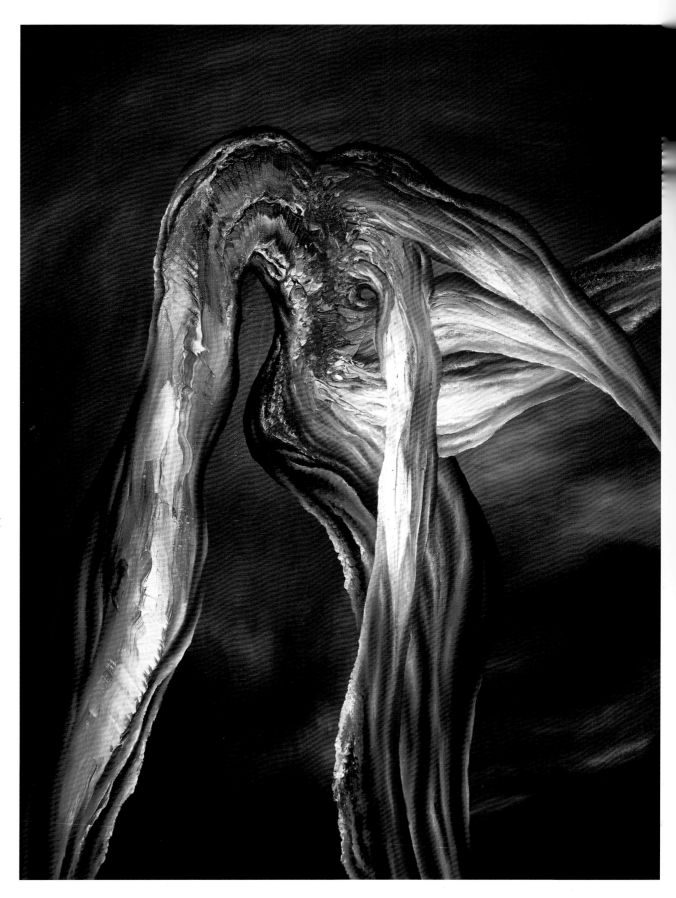

2003 作品 30 号

油画　100 × 80cm　2003 年

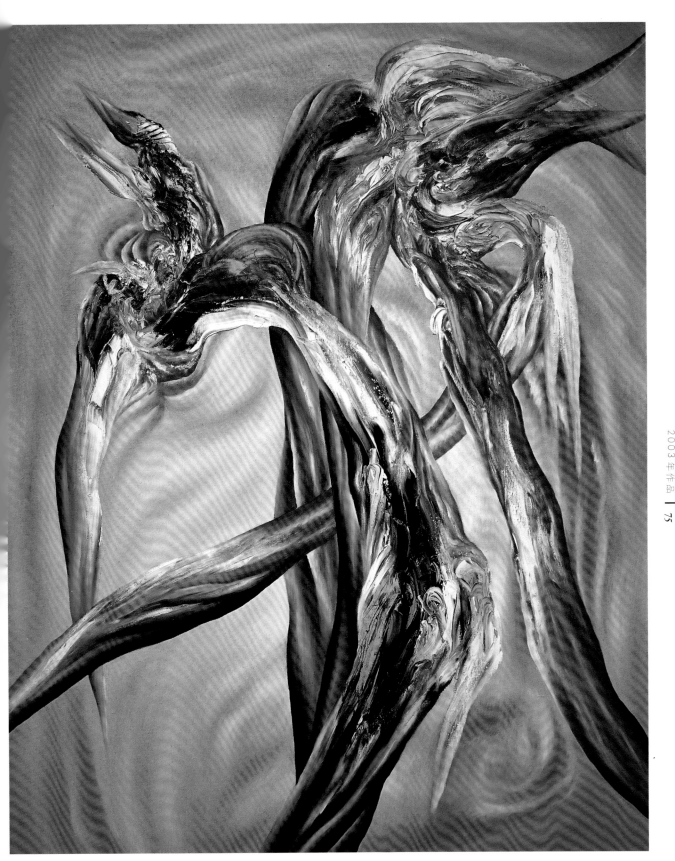

2003 作品 32 号

油画　175 × 140cm　2003 年

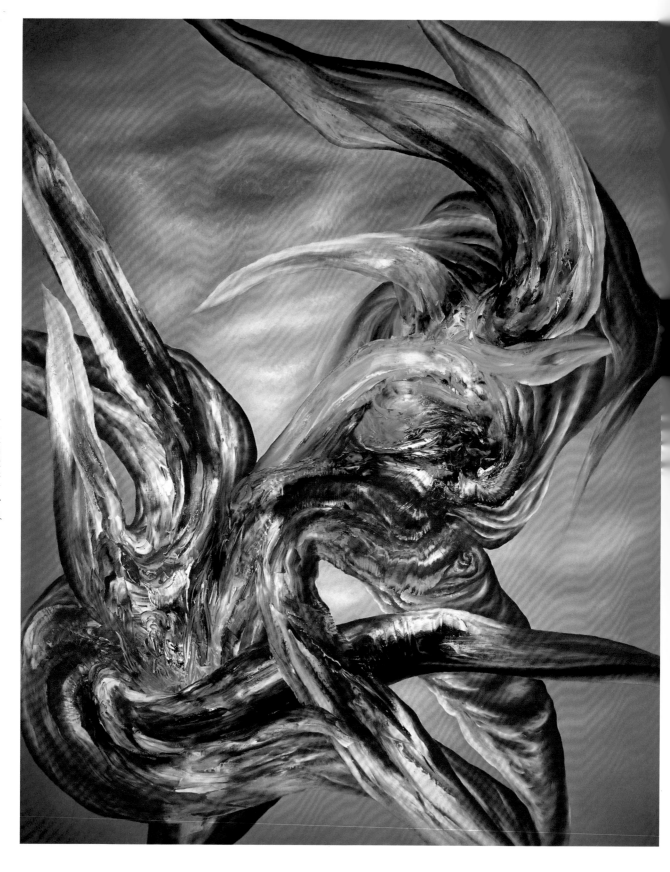

2004 作品 1 号

油画　175 × 140cm　2004 年

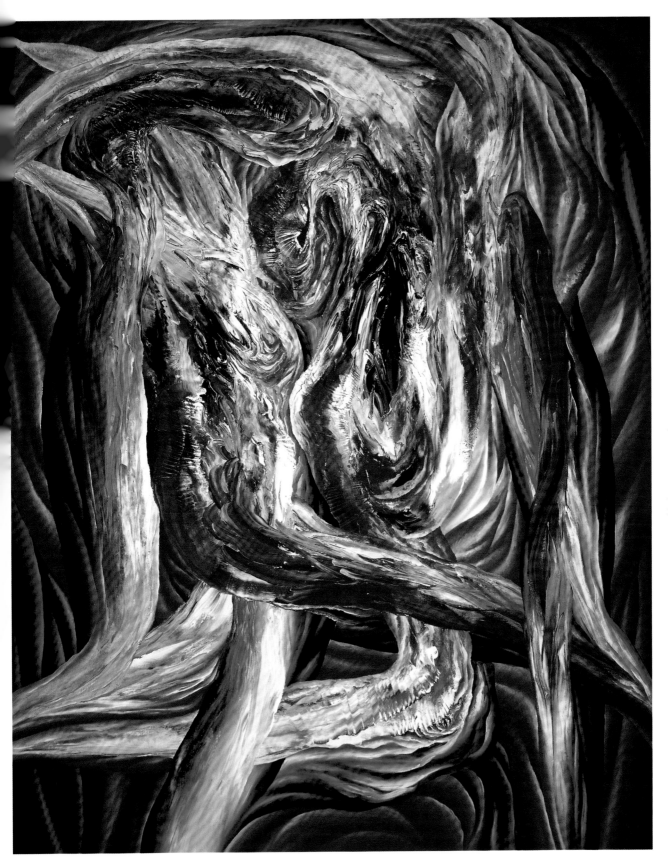

2004 作品 2 号

油画　175 × 140cm　2004 年

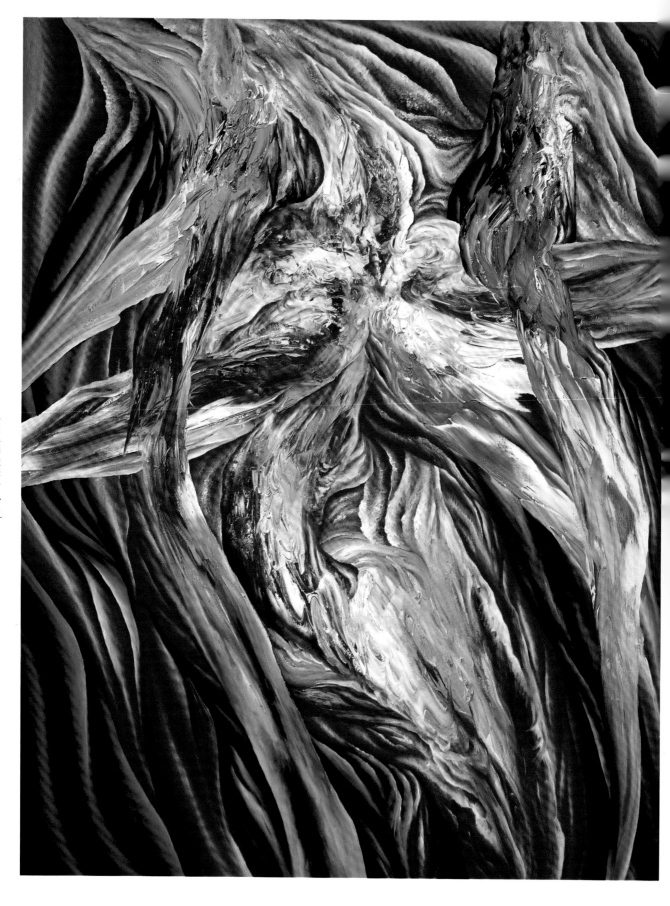

2004 作品 4 号

油画　180×140cm　2004 年

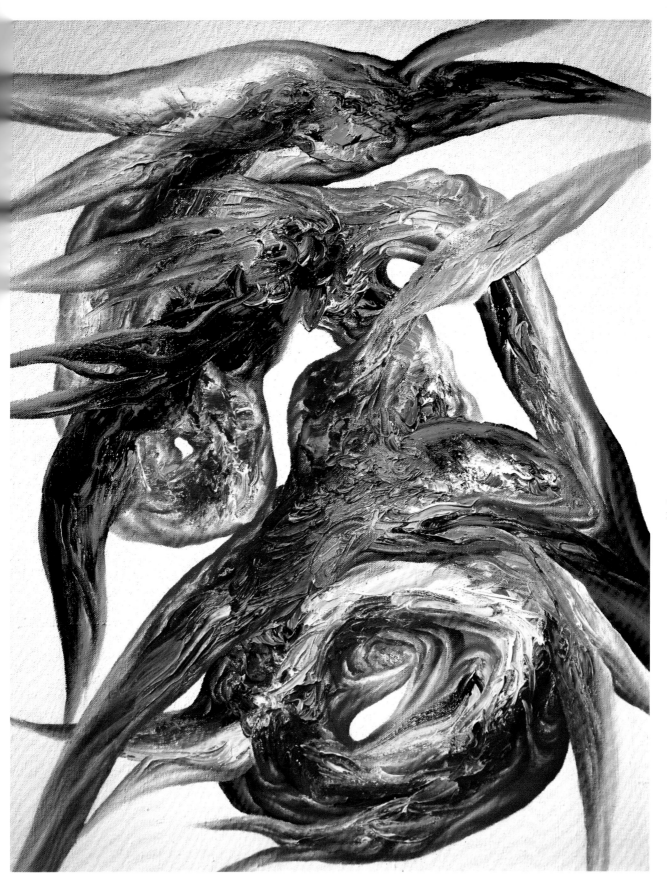

2004 作品 23 号

油画 100 × 80cm 2004 年

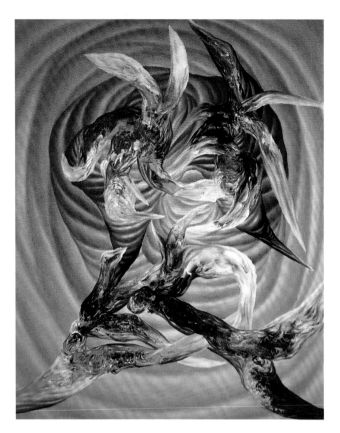

2004 作品 34 号

油画 175 × 140cm 2004 年

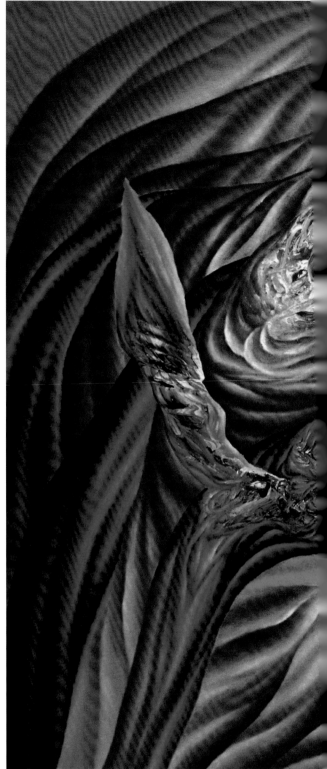

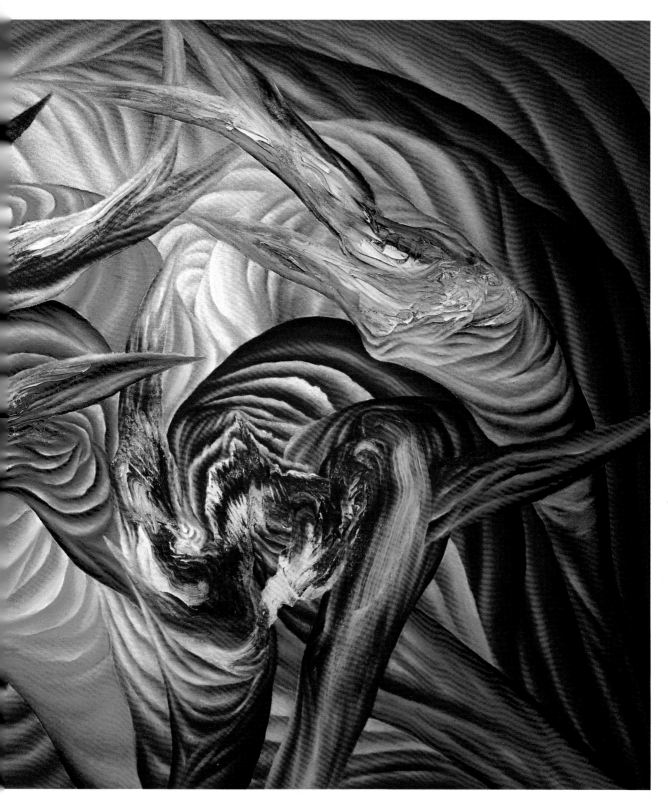

2005 作品 3 号

油画　260 × 175cm　2005 年

2005 作品 4 号 （82 页）

油画　260 × 175cm　2005 年

2005 作品 5 号 （83 页）

油画　260 × 175cm　2005 年

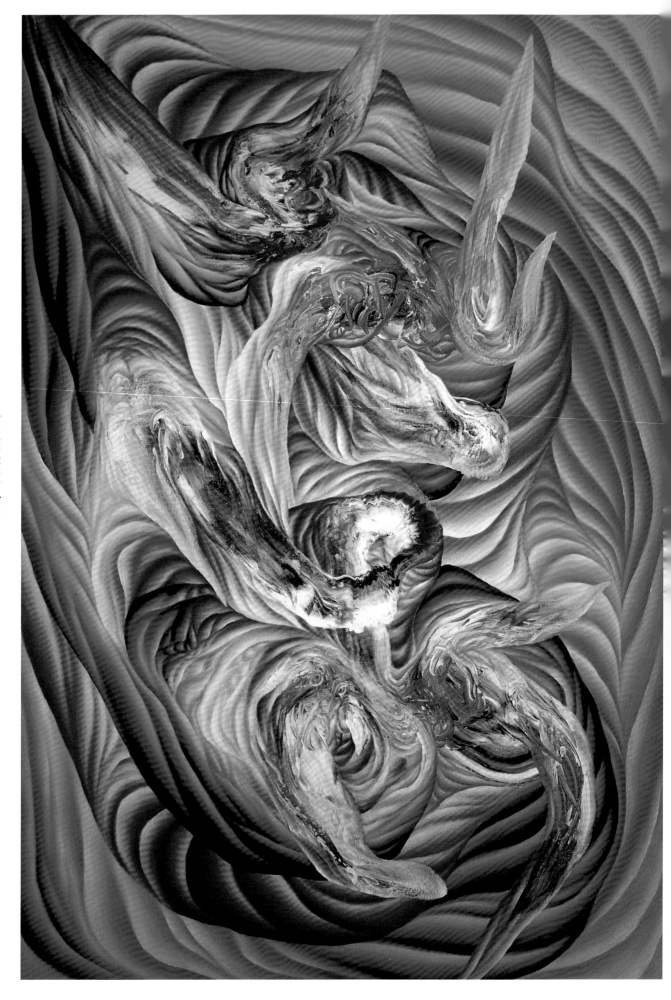

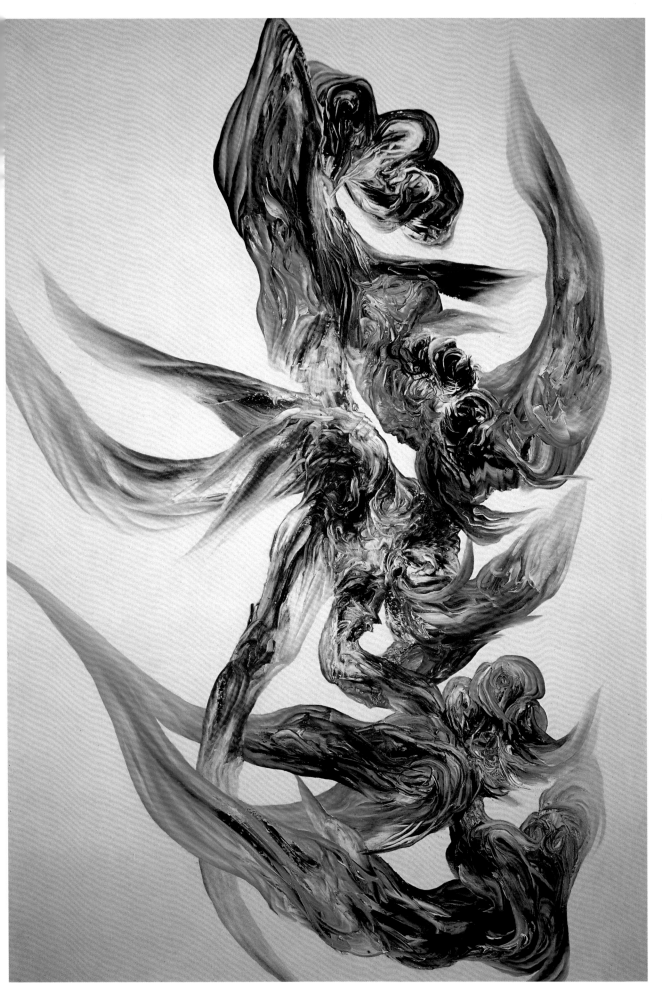

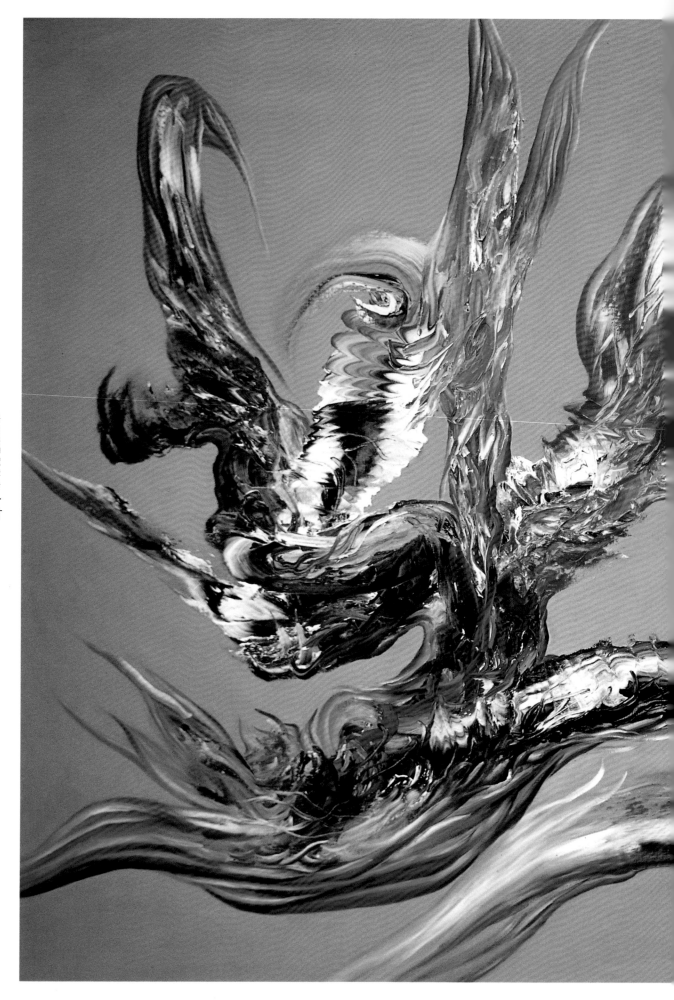

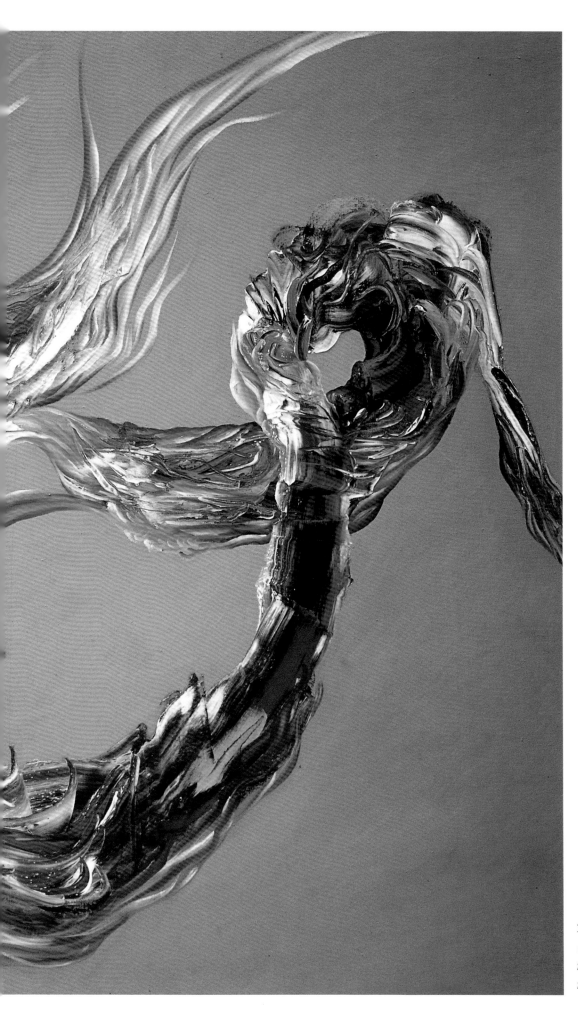

2005 作品 9 号
油画
260 × 175cm
2005 年

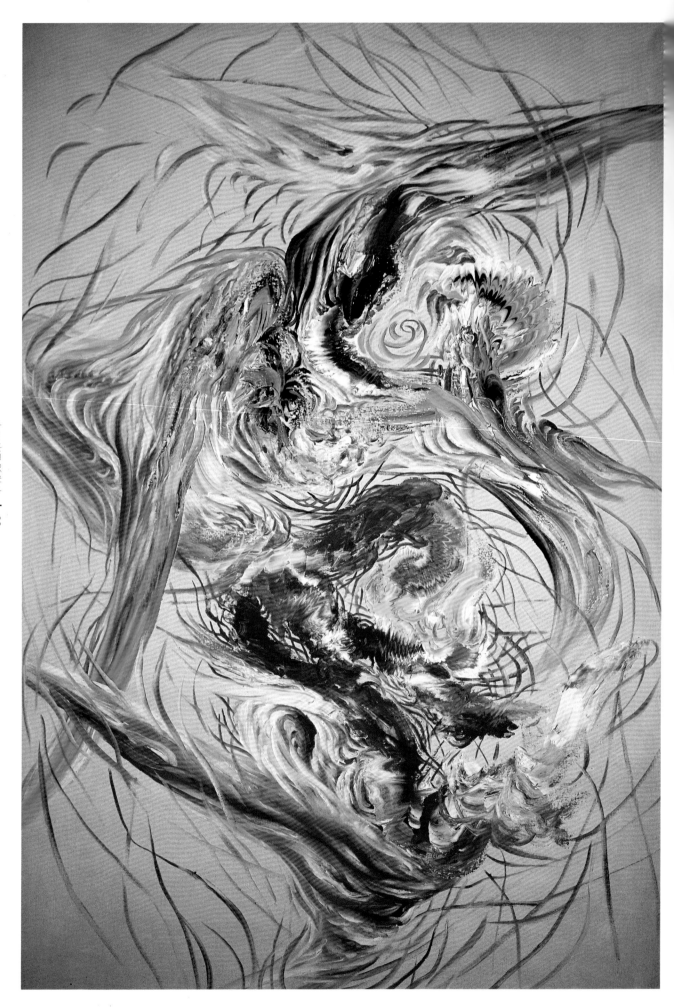

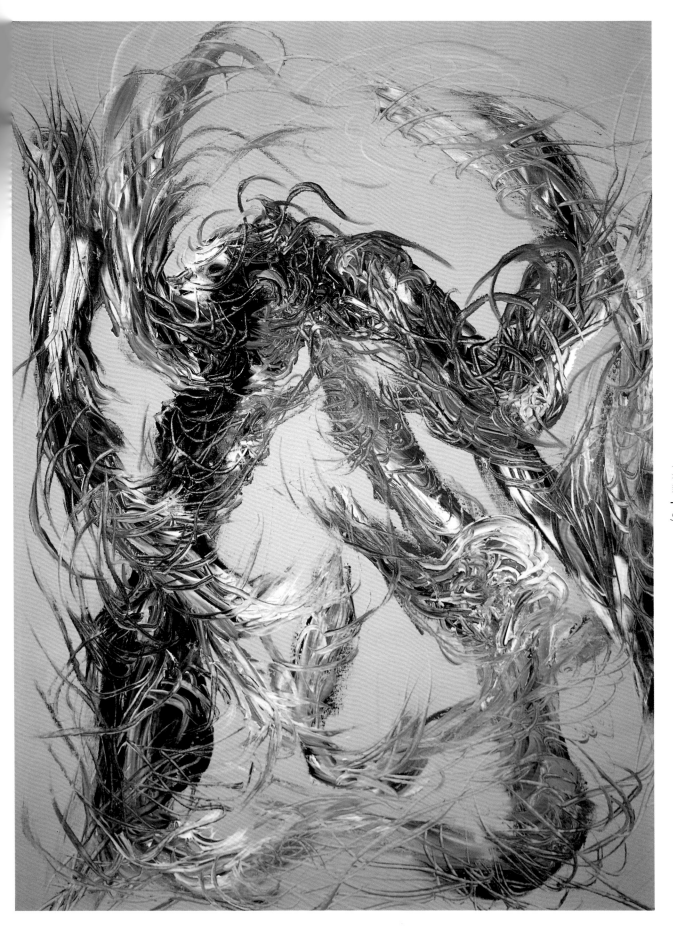

2005 作品 6 号（左页）

油画　260 × 175cm　2005 年

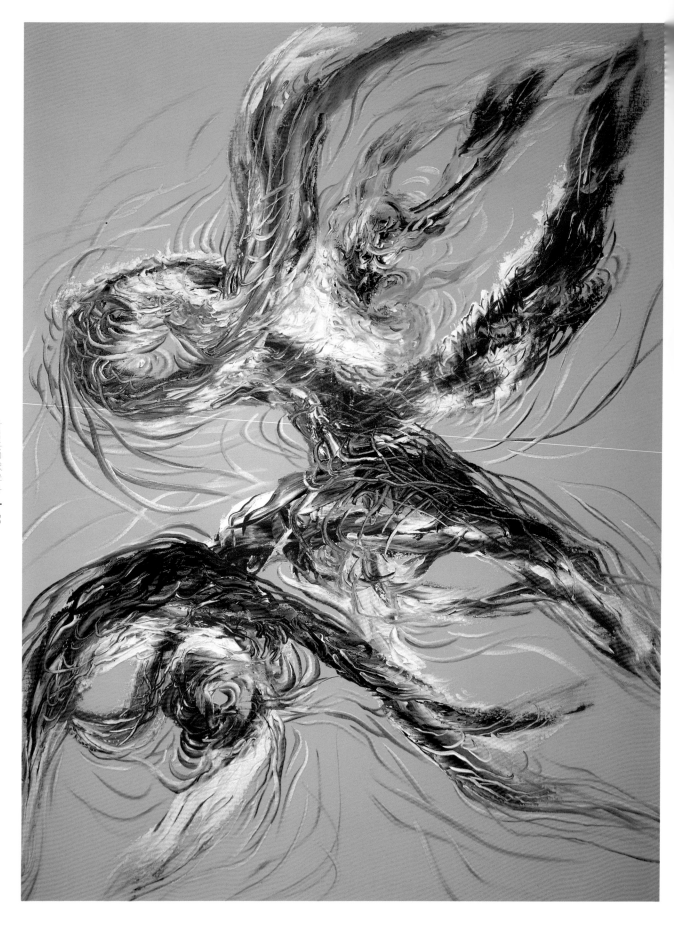

2005 作品 11 号

油画　180×140cm　2005 年

2005 作品 13 号（右页）

油画　260×175cm　2005 年

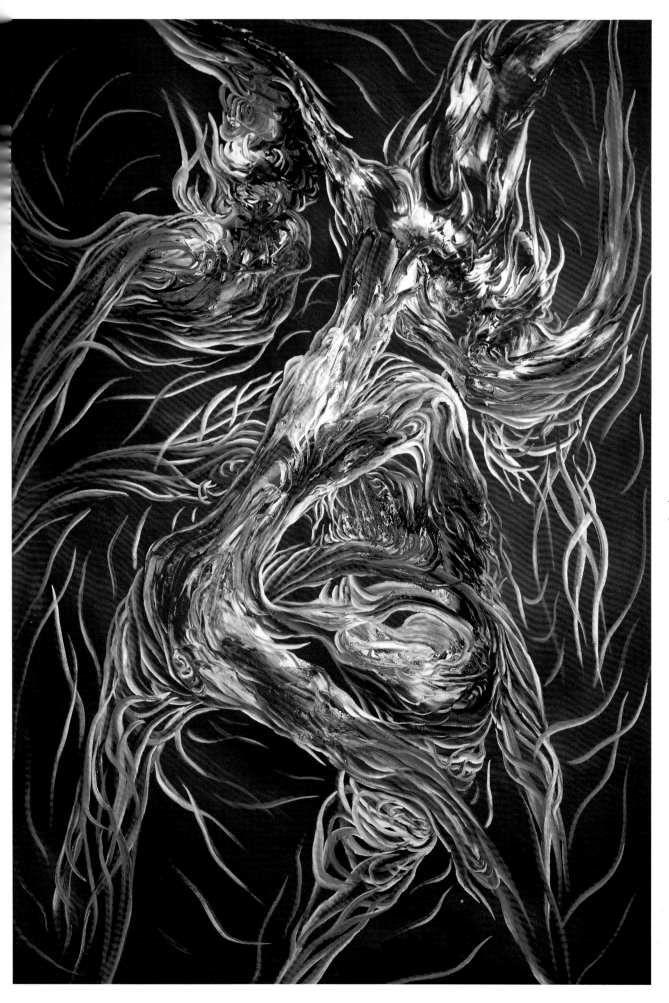

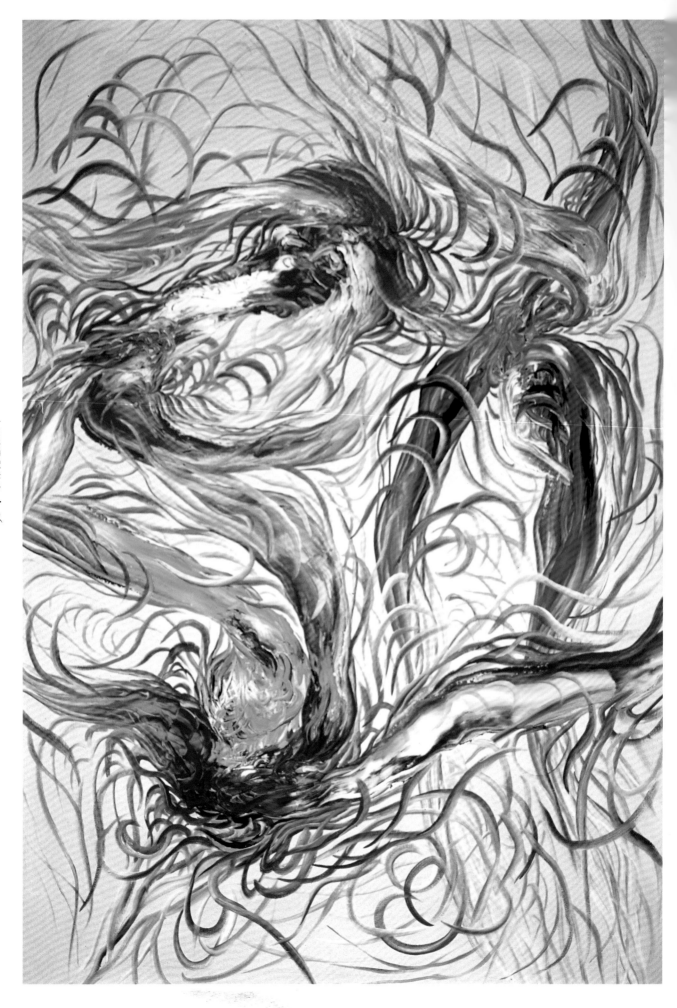

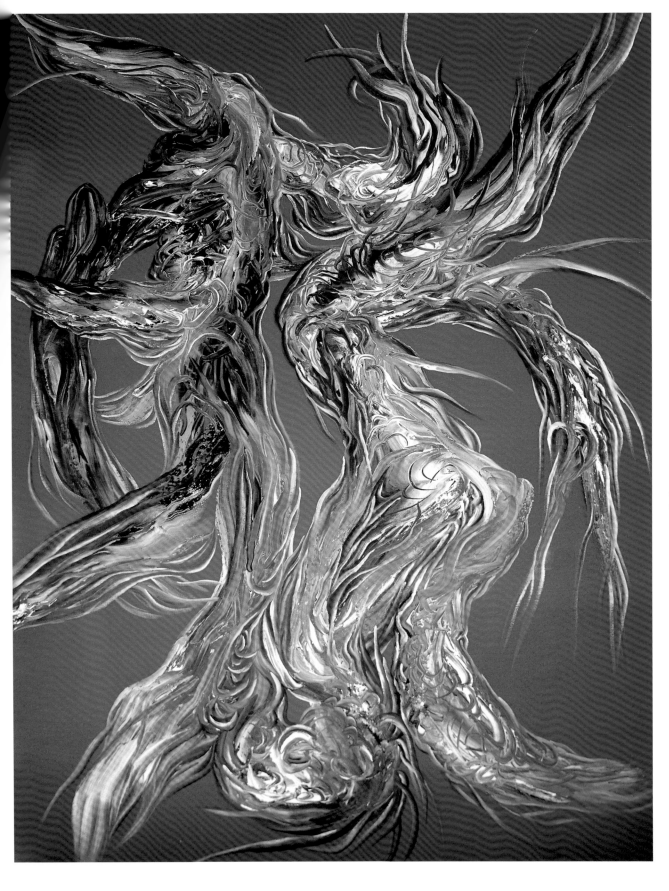

2005 作品 14 号（左页）

油画　260 × 175cm　2005 年

2005 作品 18 号

油画　180 × 140cm　2005 年

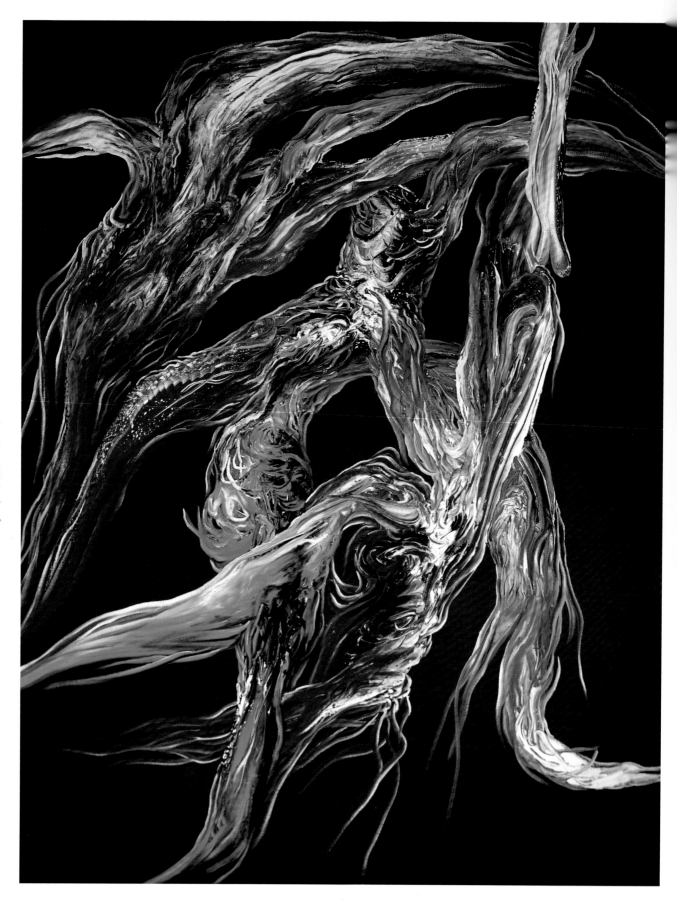

2005 作品 19 号

油画　180 × 140cm　2005 年

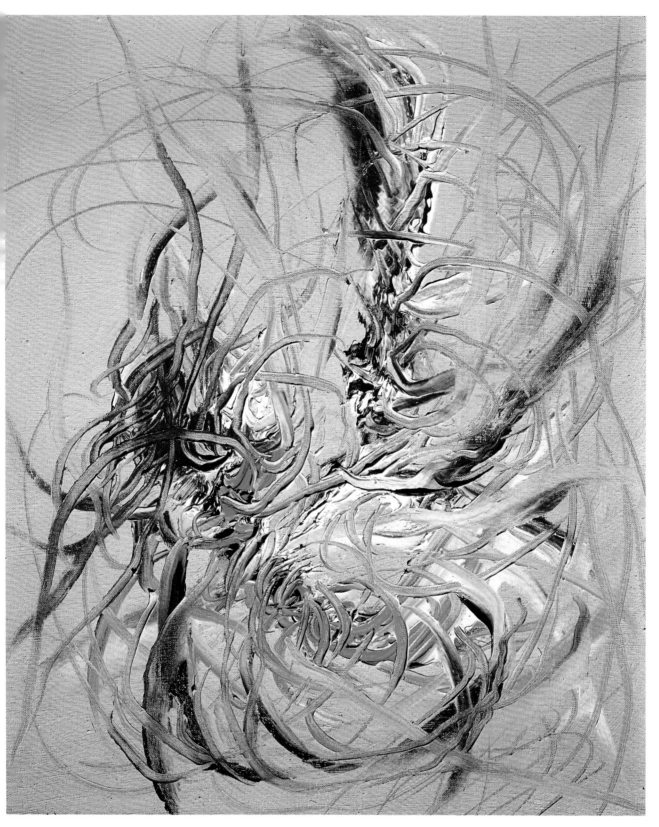

2005 作品 21 号

油画　60 × 52cm　2005 年

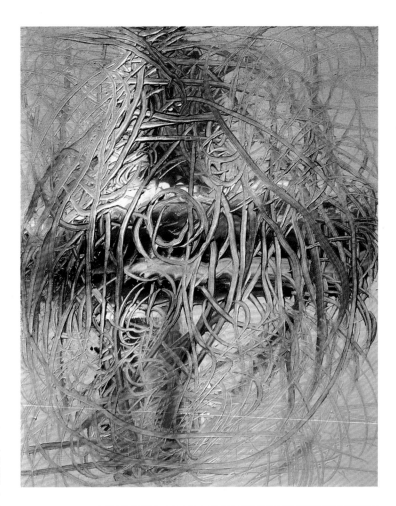

2005 作品 22 号

油画　60 × 52cm　2005 年

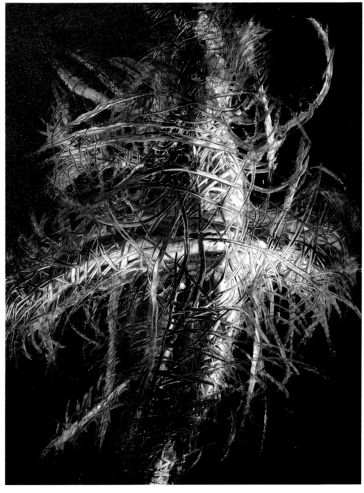

2005 作品 23 号

油画　100 × 80cm　2005 年

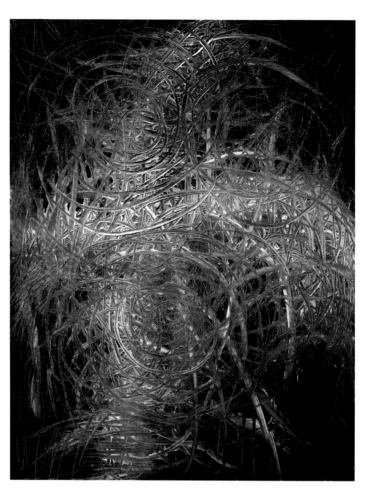

2005 作品 29 号

油画 100 × 80cm 2005 年

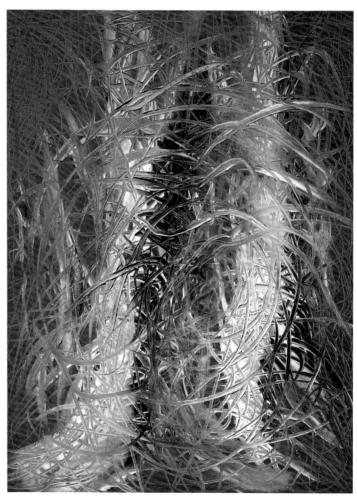

2005 作品 30 号

油画 100 × 80cm 2005 年

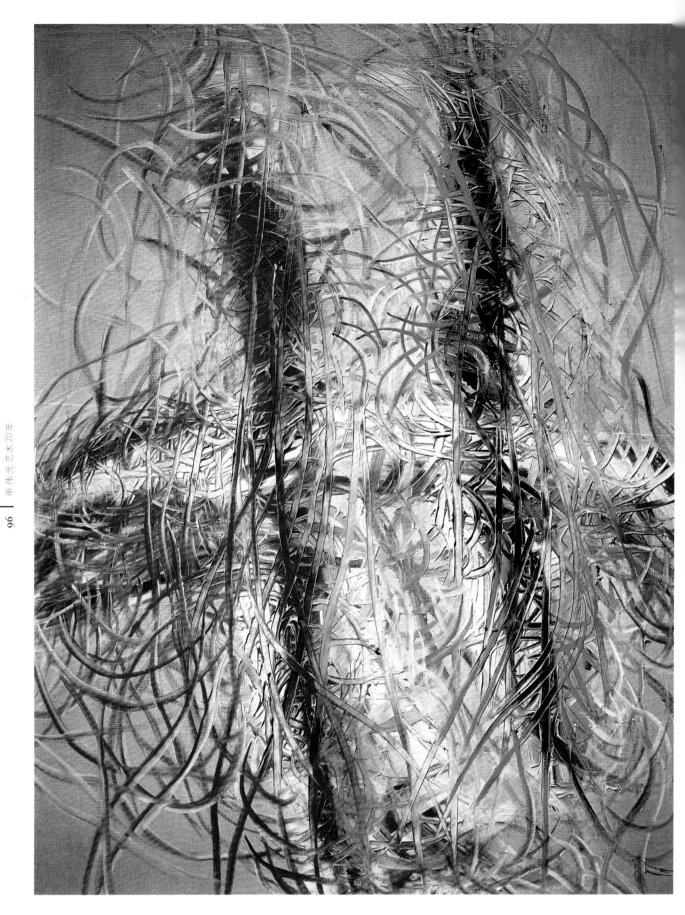

2005 作品 32 号

油画　100 × 80cm　2005 年

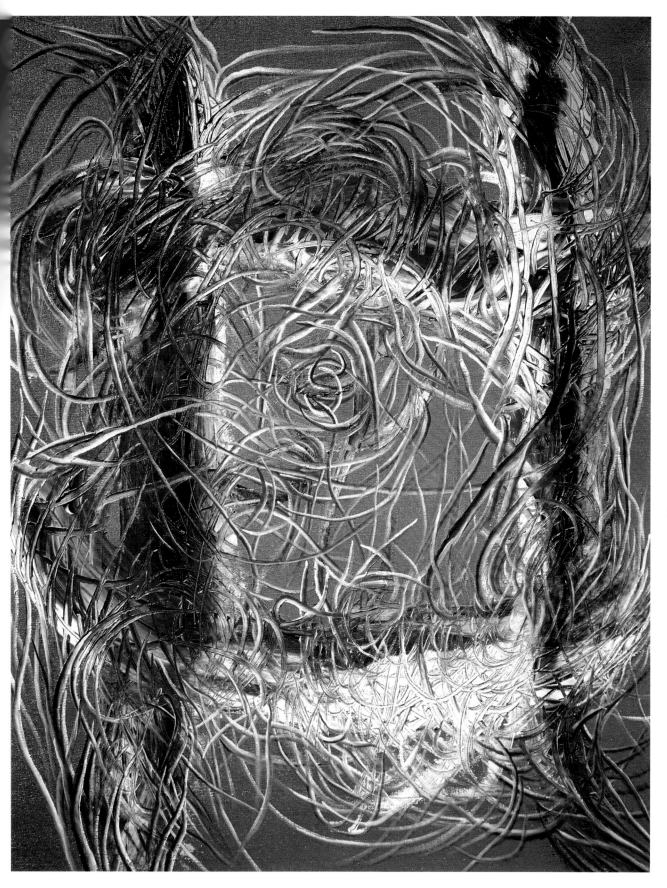

2005 作品 35 号

油画 100 × 80cm 2005 年

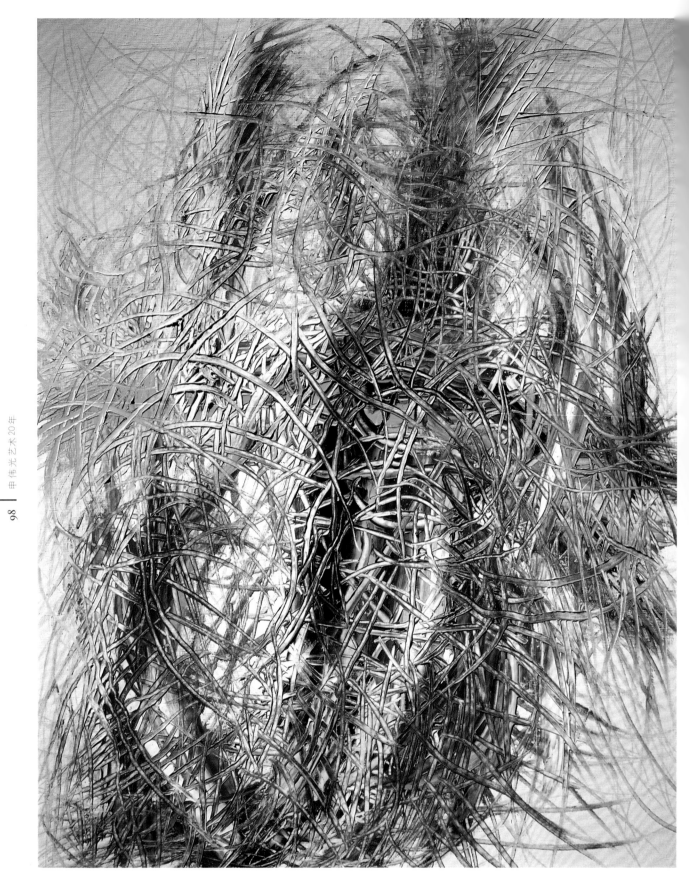

2005 作品 37 号

油画 100 × 80cm 2005 年

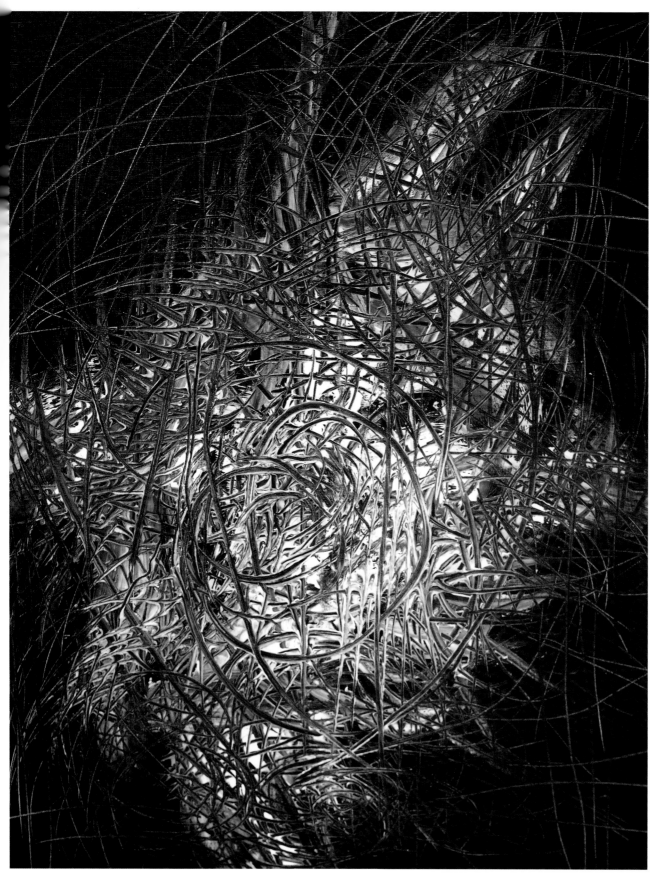

2005 作品 44 号

油画　100 × 80cm　2005 年

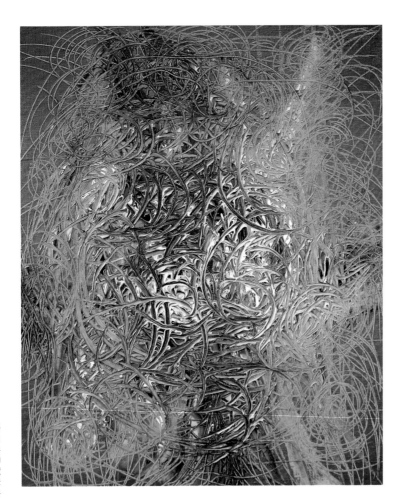

2005 作品 46 号

油画　64×52cm　2005 年

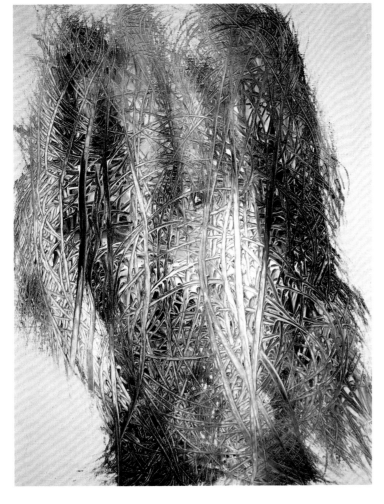

2005 作品 49 号

油画　64×52cm　2005 年

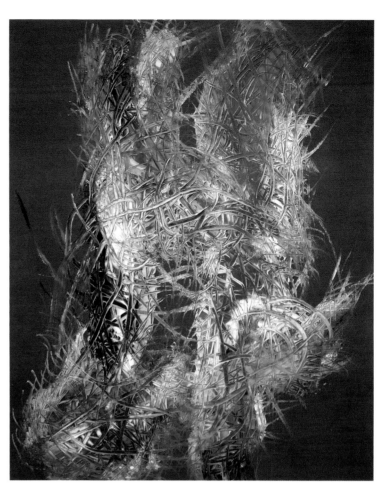

2005 作品 56 号

油画　100 × 80cm　2005 年

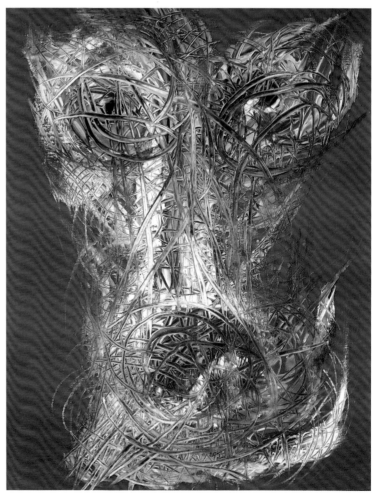

2005 作品 59 号

油画　100 × 80cm　2005 年

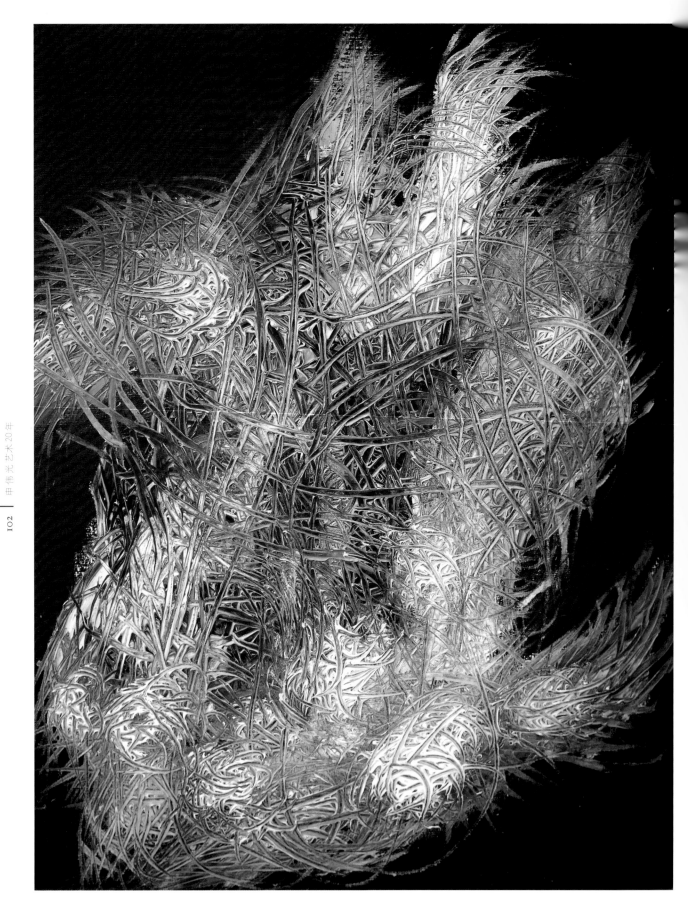

申伟光艺术20年

2005 作品 61 号

油画　100 × 80cm　2005 年

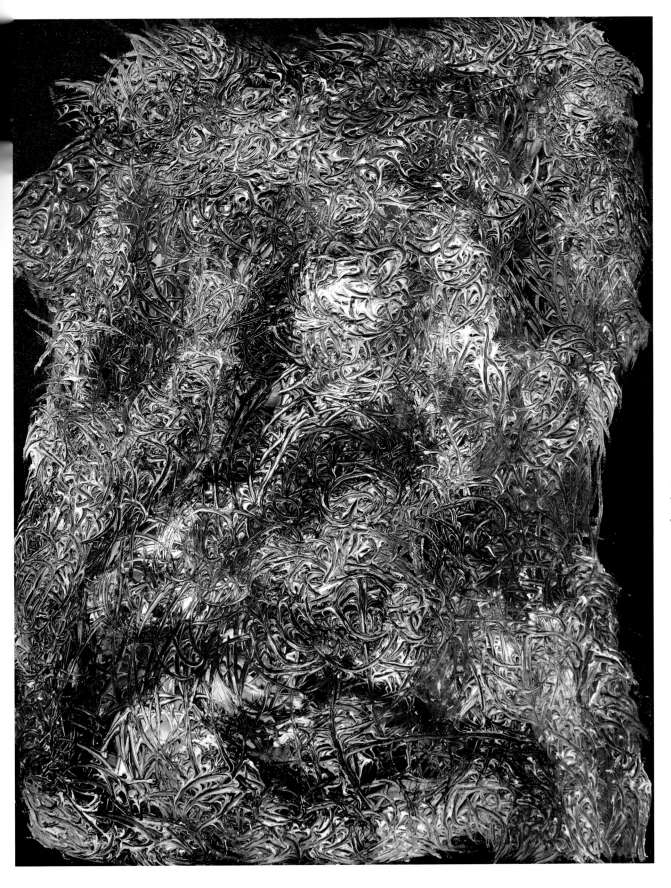

2005 作品 65 号

油画　100 × 80cm　2005 年

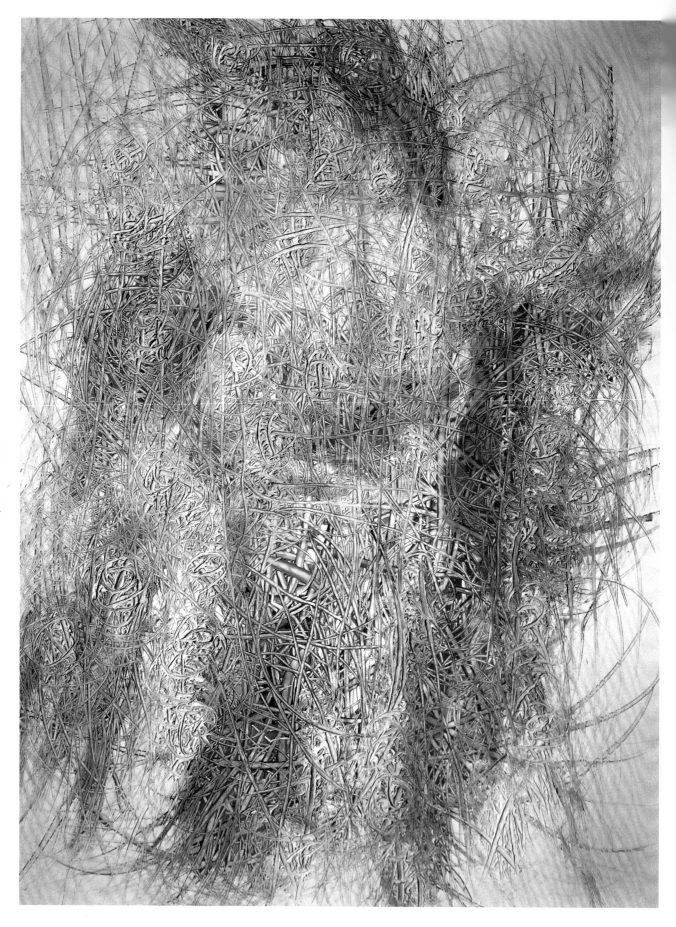

2005 作品 70 号

油画　180 × 140cm　2005 年

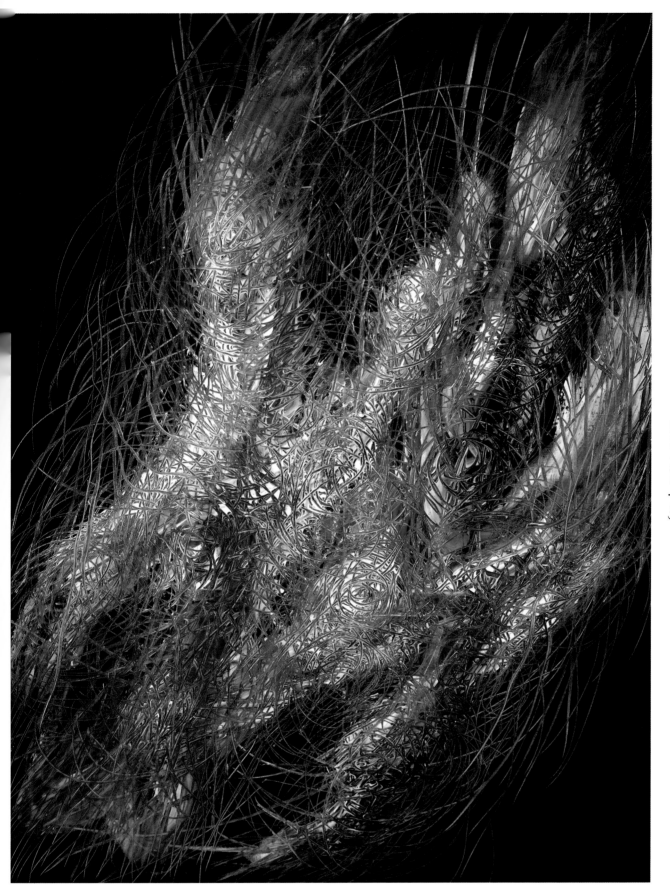

2005 作品 71 号

油画　180 × 140cm　2005 年

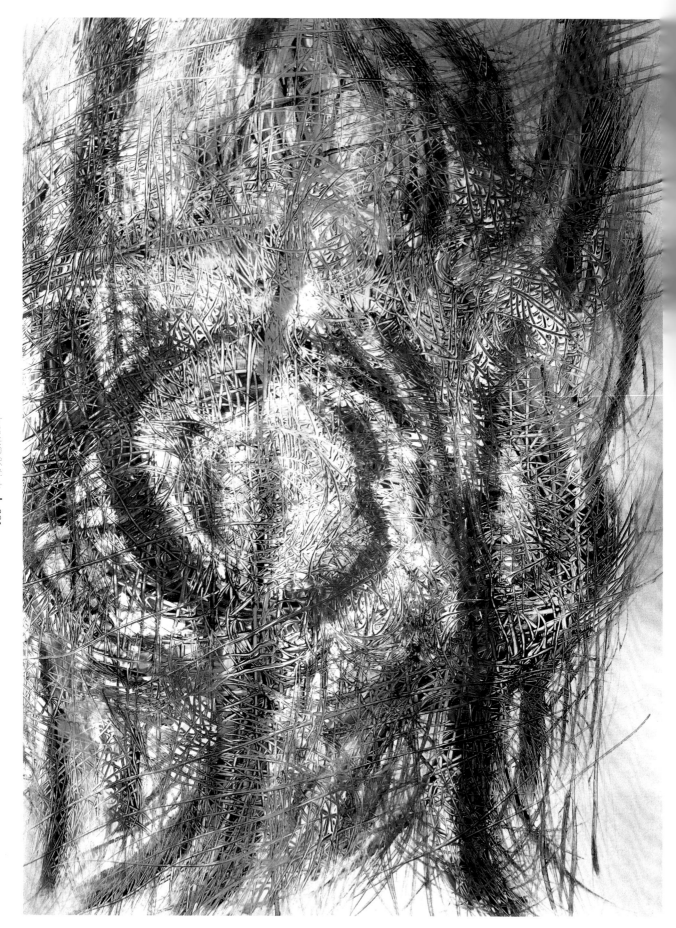

2005 作品 72 号

油画 180 × 140cm 2005 年

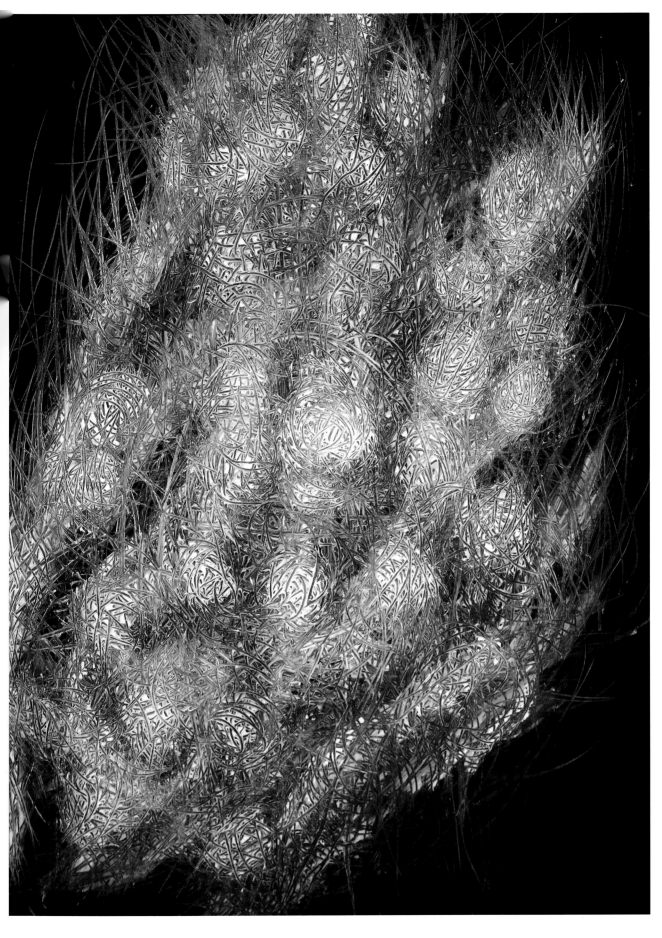

2005 作品 73 号

油画　180 × 140cm　2005 年

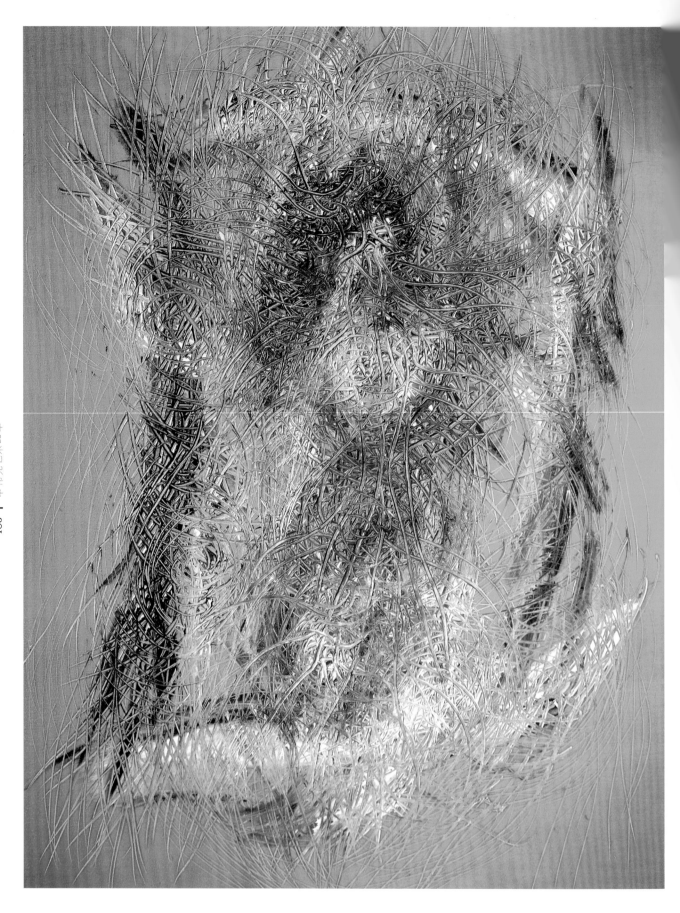

2005 作品 74 号

油画　180 × 140cm　2005 年

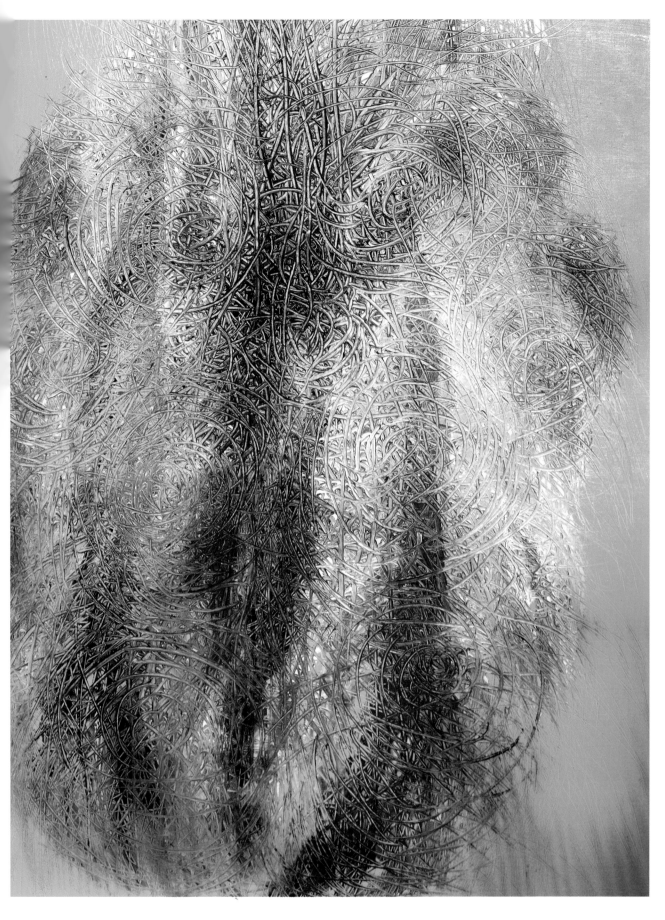

2005 作品 75 号

油画　180 × 140cm　2005 年

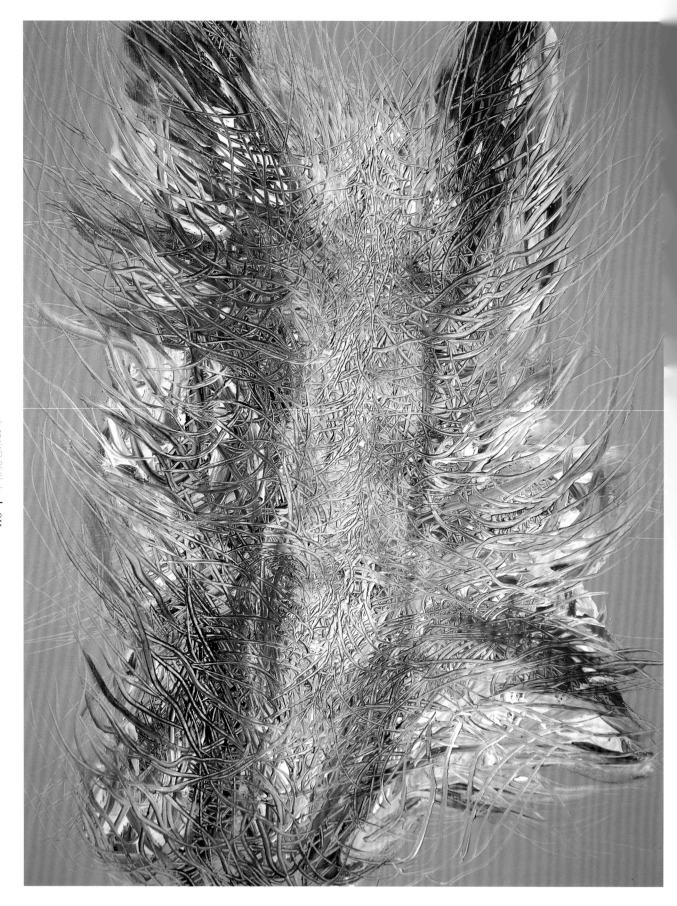

2005 作品 76 号

油画 180 × 140cm 2005 年

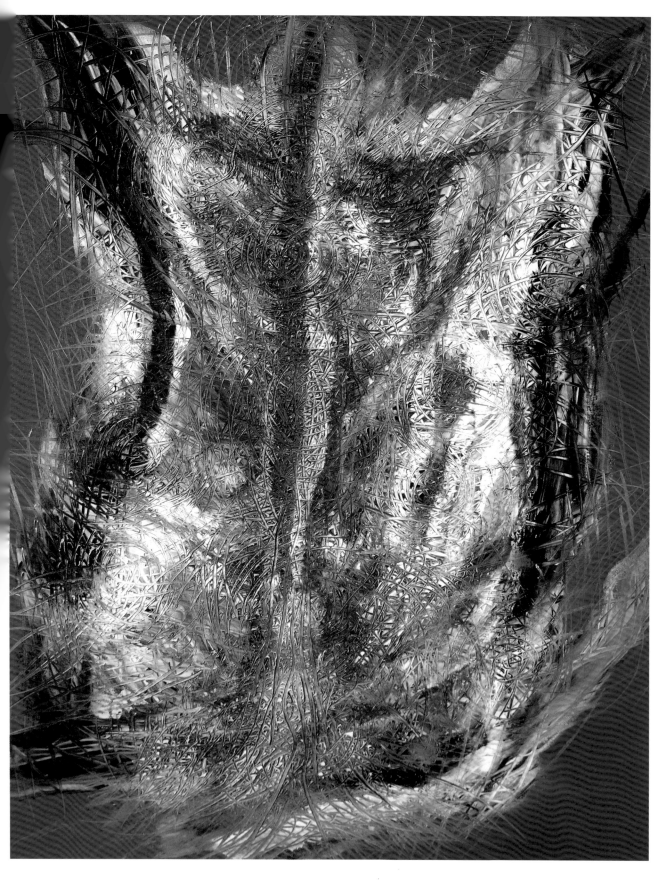

2005 作品 77 号

油画　180 × 160cm　2005 年

图书在版编目（CIP）数据

（中国艺术之旅）申伟光现代艺术20年／申伟光著.
—西安：陕西师范大学出版社，2006.1
ISBN 7—5613—3296—3
Ⅰ.中… Ⅱ.申… Ⅲ.艺术史—中国—现代
Ⅳ.J120.9
中国版本图书馆 CIP 数据核字（2005）第 154112 号
图书代号：SK5N1248

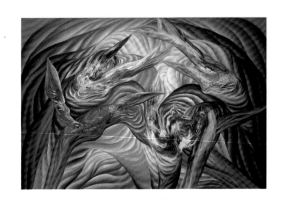

项目创意／设计制作／紫圖圖書 ZITO®

中国艺术之旅丛书

申伟光艺术 20 年

责任编辑／周宏
出版发行／陕西师范大学出版社
经销／新华书店
印刷／北京画中画印刷有限公司
版次／2006 年 1 月第 1 版
2006 年 1 月第 1 次印刷
开本／889 × 1194 毫米　1/16　7 印张
字数／5 千字
书号／ISBN 7—5613—3296—3/J·68
定价／198 元

如有印装质量问题，请寄回印刷厂调换